TALL TALES

||||||||||||||||| **A N D** |||||||||||||||||

HALF TRUTHS

★ ★ ★ **O F** ★ ★ ★

BILLY
THE
KID

J O H N L E M A Y

FOREWORD BY ELVIS E. FLEMING

THE
History
PRESS

Published by The History Press
Charleston, SC 29403
www.historypress.net

Copyright © 2015 by John LeMay
All rights reserved

Cover photographs courtesy the Historical Society of Southern New Mexico.
Back cover drawing, *The Ghost of Billy the Kid*, by Jared Olive.

First published 2015

Manufactured in the United States

ISBN 978.1.62619.996.5

Library of Congress Control Number: 2015934857

For the wolf pack, with whom I have roved the wilds of Lincoln and the skyscrapers of Seattle.

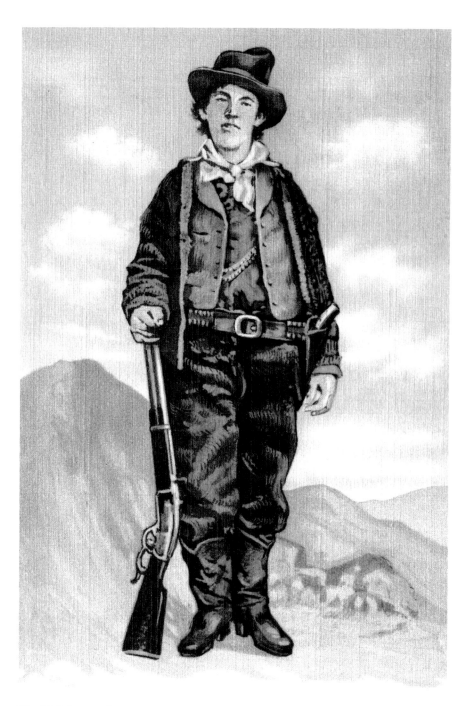

The Kid's famous tintype as a colorful postcard sold to tourists in the 1940s. *Historical Society for Southeast New Mexico, #914.*

CONTENTS

FOREWORD

One approaches the task of writing "another book about Billy the Kid," or another book about the Lincoln County War, with much fear and trembling. Most of us who have written on the subjects did so only after many years of study and contemplation, and we decided at length that perhaps we had something to add to the story. Hence, there seems to be no end to the myriad books on what are arguably New Mexico's most famous historical event and its most notorious denizen.

Probably most of the literature pertaining to Billy the Kid is of dubious veracity to some extent or other. Those stories did not have to be true to be useful in this study, as the emphasis is "Tall Tales and Half Truths of Billy the Kid." John LeMay has done a yeoman's job of ferreting out every imaginable source—scholarly works, popular books, pulp magazines, newspaper articles, folklore and old-timers' accounts on the Kid and the context of his career—to compile a narrative that seeks the truth about said stories. There is no other book like this one. If a story surfaces that is illogical, weird or obviously not true, no problem. John has taken those stories and researched them to determine whether there is a grain of truth or not. He gives his opinion of the origin, the truthfulness or lack thereof and the importance of the stories. And in those cases where the truth is elusive, he uses his vast knowledge of the situation and his grasp of the context to extrapolate conclusions about what likely happened or what was unlikely to have happened.

The end product of John LeMay's work is a useful and quite readable book on Billy the Kid that contains many details about his life and adventures, as

well as those of his doppelgangers after Billy was gone. All in all, it makes for a very entertaining read, and the author is to be commended for the effort it took to compile this book. While the text identifies John's sources, complete with reference notes, at the same time the narrative is written in a rather informal and at times even humorous vein.

Anyone who wants to develop a broader understanding of Billy the Kid should have this book. It is apparent that some aspects of Billy's life and career will never be known for sure and certain. In this day and age in which Billy the Kid is a major generator of tourist dollars for New Mexico, do we really want to know the whole truth, and nothing *but* the truth?

ELVIS E. FLEMING
Professor Emeritus, Eastern New Mexico University
Former Chief Archivist, Historical Society for Southeast New Mexico
Author of *Captain Joseph C. Lea: From Confederate Guerrilla to New Mexico Patriarch*
Roswell, New Mexico

ACKNOWLEDGEMENTS

First off, I'd like to thank Bonnie Montgomery of the Historical Foundation for Southeast New Mexico for connecting me to The History Press and also all the researchers and archivists who helped me with the text and to gather photographs. Among them are Elvis Fleming; Lynda Sanchez; Tom Carey; Larry Knadle; Tina Williams; Amy Davis; Jared Olive; Morgan Nelson; Frederick Nolan; Earl Pittman; Gary Cozzens; Angel Mayes; William Cox II; Jacquelyn Reese and Sara Bogumil at the University of Oklahoma; Beverly Strauser of the Dolan Tea House; Daniel Kosharek, photo curator at the Palace of the Governors Photo Archives; Megan Laddusaw, Hilary Parrish and Emily Kirby at The History Press; and also the good folks from the Facebook group dedicated to the Lincoln County War and Billy the Kid. I would like to point out that almost all the work for this book was done in the Elvis E. Fleming Room of the Historical Society for Southeast New Mexico Archives Building (hereby referred to as the HSSNM for photo credits). It offers a wealth of documents, books, magazines, interviews, unpublished manuscripts and photographs and, for my money, is one of the greatest untapped research centers in New Mexico. For more information, visit RoswellNMHistory.org or call the HSSNM at (575) 622-8333.

A GOOD OL' FASHIONED THROWBACK

Somewhere, as you read this, a writer is sitting down at his typewriter to startle the world with a new version of aspects of the Kid's life.
—*J. Walter Flynn, editor,* New Mexico Magazine, *August 1960*

Another book about Billy the Kid. Aren't there too many already? Yes, while this is indeed yet "another book on Billy the Kid" (actually, that's what this author wanted to call this book before cooler heads prevailed), it is unlike any book on the Kid written recently. Rather than beating the perennial dead horse of the Lincoln County War, of which the Kid was the star participant in the late 1870s, this tome explores the lesser-known facets of his life. While most Billy buffs are well aware of his famed escape from the Lincoln County Courthouse and his eventual (and some will say alleged) demise at the hand of Pat Garrett, most are probably unaware of his other reputed adventures. These have included his search for the Lost Adams Diggings, his penchant for cross-dressing to evade the law and his appointment to the sainthood in Escondida. Especially intriguing are his escapades in the postmortem (rather, they were in the spiritual realm), such as the ghostly figure seen carrying a cross in the Fort Sumner cemetery, or in the form of imposters and Kid claimants like Brushy Bill Roberts, who claimed to have ridden with Pancho Villa and lived next door to Jesse James, among other crazy things.

If you haven't heard any of these tales before, that's because in recent years authors have taken a more respectable angle on the Kid, sticking strictly to the facts. And let's face it, that's no fun. What one will find here is

the best folklore and far-out stories to ever emerge on William H. Bonney, alias Billy the Kid—or, in other words a throwback to the good ol' days of yonder. Back in the heyday of Kid folklore, which encompassed the time of his death in 1881 all the way up until the 1950s, any old-timer within the state of New Mexico could claim that they once knew the Kid. If she were a woman, she might claim to have once hidden him from the law or even claimed to be one of his girlfriends. If a man, chances are he rode with, shot at or was shot at himself by the Kid. After all, who could prove them wrong in the days before the information age in which we now live?

Directly after being gunned down by Sheriff Pat Garrett in Fort Sumner on July 14, 1881, the Kid became a dime novel sensation and, within a year of his death, had eight books to his name. In 1882, Pat Garrett authored a book on Billy by way of his ghostwriter, Roswell postmaster and journalist Ash Upson. Breathlessly titled *The Authentic Life of Billy the Kid, the Noted Desperado of the Southwest, Whose Deeds of Daring and Blood Made His Name a Terror in New Mexico, Arizona, and Northern Mexico* by Patrick F. Garrett, "Sheriff of Lincoln County at Whose Hands He Was Killed," it was actually full of fabrications. As Garrett knew little of the Kid's early days, half of the book was therefore more or less fictitious. J.W. Hendron, a journalist himself, once remarked that these early accounts of Billy's life read "like a press agent's yarn," which they were.

Eventually, the Kid's popularity faded away. A massive resurgence in interest occurred after the 1926 publication of *The Saga of Billy the Kid* by Walter Noble Burns. Although Burns interviewed numerous old-timers in Fort Sumner and Lincoln and told historian Maurice G. Fulton that his "whole purpose was to get authentic facts," the resulting book was full of mythic embellishments, some of which Burns made up himself like Ash Upson before him. Some of these stories had a slight grounding in fact, even the tale of Susan McSween playing "The Star-Spangled Banner" on the piano as her house went up in smoke during a shootout. The story was apparently sparked by the rumor that bullets occasionally struck the keys of her piano during the battle. Though Mrs. McSween refuted the story, Burns couldn't resist placing it in his book anyway. Upon publication, *Saga* became an instant classic. In the retrospective words of Frederick Nolan in his *The West of Billy the Kid*, Burns's book brought the Kid back to life "like some long-buried vampire from whose heart the stake has been unwittingly removed." After *Saga*'s success, old-timers came out of the woodwork to tell about the time that they rode with Billy the Kid. Newspapers were rife with their remembrances and stories, which were printed from the 1920s all the way up until the late 1950s, when most of them had finally passed away. The telling of these tales was even promoted in a roundabout way by President Franklin D. Roosevelt,

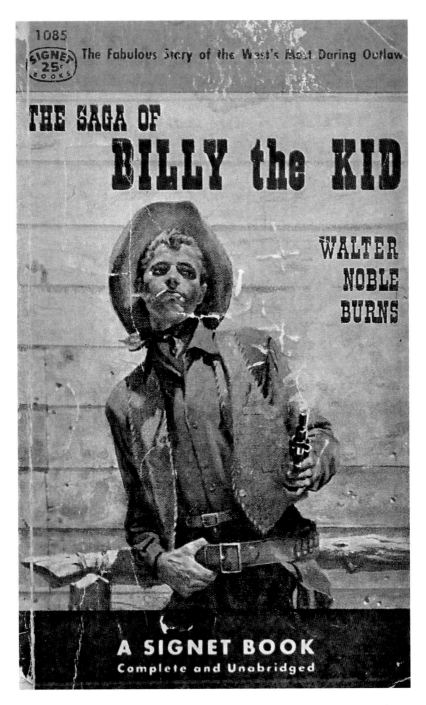

The Kid's look in this 1953 reprint resembles James Dean, who was set to star in *The Left Handed Gun* before his death. *Author's collection.*

THE LEGEND OF BILLY THE KID: JUST A SANTA FE RING CONSPIRACY?

In his unpublished manuscript, "The Cover-Up Behind the Legend of Billy the Kid," author Kenneth F. Osthimer puts forth the interesting notion that Billy the Kid's posthumous legend was created by the Santa Fe Ring, which secretly ruled the New Mexico Territory in the 1800s. In essence, the Kid's legend was created and immortalized to draw attention away from the Ring's land-grabbing antics in the Lincoln County War. In Osthimer's own words, "Pro-Ring writers slur over or 'omit' discussion of such Ring activities and center their attention on the alleged activities of Billy the Kid." Among these alleged pro-Ring writers was Ash Upson!

who established the WPA (Works Progress Administration), a work relief program during the Great Depression. Out of this was born the Federal Writers' Project, geared at interviewing old-timers for historical portraits. In southeastern New Mexico, talk among the old-timers focused heavily on Billy the Kid and the Lincoln County War. Along the way, old legends were repeated and a few new ones created. Also common in this era from time to time were modern sightings of the Kid, who was believed to be not really dead and just visiting stateside from Mexico. These fun articles have been long forgotten in favor of more grounded, historically accurate tales.

This is because in recent years it has become in vogue to try and dig up some startling new fact or evidence of the Kid's real life or perhaps just write another biography on him that is slightly more in depth than the last one. As stated earlier, this is not any such book. This volume is proudly and intentionally made up of the hearsay of the old-timers. So one could think of this as the "Unauthentic Life of Billy the Kid" (another title the author was fond of). Nor in this book will you find yet another recap of the Lincoln County War and the complete life and times of Billy the Kid, as space does not permit and there exist enough books on that as there is. To quote one of Billy's early obituaries from the *Grant County Herald*, "The general facts of his desperate career are well known and need not be recounted here." And neither do you likely even need them to be recounted if this book piqued your interest—you likely already know them. With no more ado, here are the many forgotten and discarded tales of Billy the Kid. A few of them might even be true.

OF TOMBSTONES AND TRIGGER FINGERS

THE KID'S FIRST
ADVENTURES POSTMORTEM

Here in his nameless grave on the dreary, windswept Pecos flats under the sun and rain and drifting snows, the boy of the tiger heart rests at last in peace.
—*Walter Noble Burns,* Saga of Billy the Kid

Contrary to the above quotation, Billy the Kid most certainly does not rest in peace. Stories of attempts to mutilate and/or dig up the Kid began circulating immediately after he was buried. And due to several historical events, it's entirely possible the Kid's body was even moved to Santa Fe in 1906. Not to mention the Kid's grave markers (there have been four in all) have all been either shot, stolen or destroyed—and sometimes a combination of all three—several times. As a result, the Kid undoubtedly possesses the world's most notorious grave site, and oddly, it would seem Billy's lifeless corpse has had nearly as many adventures as he did.

It could be said that the Kid's legend only truly began at his end. Billy's obituaries, which ran in papers as far away as London, were fairy tale–like, the most obscene belonging to the Santa Fe *Weekly Democrat*, which reported after the Kid hit the floor dead that a strong odor of brimstone filled the room. Accompanying the brimstone was the very devil himself to take Billy's soul, at least according to the *Weekly Democrat*. The pastor at Billy's funeral, on the other hand, read from the fourteenth chapter of Job ("A man that is born of woman is of few days and is full of trouble—he fleeth like a shadow and continueth not") and closed his sermon

HUGH LEEPER, THE "SANCTIFIED TEXAN"

Ironically, the pastor who performed Billy the Kid's funeral service was rumored to be a wanted man himself for committing an unknown crime in the South. The man was a buffalo hunter named Hugh Leeper and is described in detail by Colonel Jack Potter in his article called "The Sanctified Texan" after Leeper's alias. Leeper knew the Bible well, and some even claimed he had prophesied the Kid's death, being a firm believer in predestination and often preaching about how someone's "time had come." Whether he prophesied the Kid's slaying or not, Leeper's next prediction—the destruction of Beaver Smith's Saloon, a "curse of civilization"—actually occurred a few years later when it was swept away by the Pecos River. Leeper eventually cleared out of town when it was discovered that he was a fugitive. One of Pat Garrett's notorious deputies, Barney Mason, had lost everything he had—including his clothes—in a poker game. In his coat pocket were some "wanted" papers, one of which was for a man of Leeper's exact description. When Leeper was told of this, he said to a friend, "Well, just tell the folks that my time has come to move on. I'll be seeing them when the Roll is Called Up Yonder. Adios!"

by stating, "Billy cannot come back to us, but we can go to him and will see him again up yonder, Amen."[1]

Billy was buried in the Old Military Cemetery next to two of his *companeros*, Charlie Bowdre and Tom O'Folliard; all three were killed by Pat Garrett. Billy was buried in a casket made up of ceiling planks off an old dirt-roofed adobe building, long since abandoned, or so legend says. The builder was at one time rumored to be Domingo Swabecher, the son of a German immigrant soldier, though Jesus Silva is the man who really built it and gives a detailed account of the process in Miguel Antonio Otero's *The Real Billy the Kid*.

BILLY'S BONES

Like that of any historic figure, Billy's corpse was immediately in danger of macabre souvenir hunters. The first story regarding the mutilation of the Kid's body appeared in the July 25, 1881 edition of the *Las Vegas Optic* in their now infamous "The Fatal Finger" story:

TALL TALES AND HALF TRUTHS OF BILLY THE KID

An esteemed friend of the Optic *at Fort Sumner, L.W. Hale, has sent us the index finger of "Billy, the Kid," the one which has snapped many a man's life into eternity. It is well preserved in alcohol and has been viewed by many in our office today. If the rush continues we shall purchase a small tent and open a side show to which complementary tickets will be issued to our personal friends.*[2]

Though for many years this story was thought to be a hoax, professor emeritus Robert J. Stahl wrote a lengthy piece on the trigger finger in a recent edition of *True West* magazine. Stahl relates that people did in fact trek to the *Optic* office to see a finger in jar—whether it was really Billy's or not is unknown—and reportedly they were allowed to see it so long as they paid three dollars for a yearlong subscription to the paper. The mysterious donor, L.W. Hale, was a real New Mexico resident and a first-class peddler, selling anything he could. A relative once said of him, "He was a wheeler and dealer, but always an honest and fair wheeler and dealer."[3] The family also confirmed Hale was indeed in the Fort Sumner area at the time of the shooting and was a friend of *Optic* editor Russell A. Kistler. Stahl speculates that Hale could have bought the finger off one of Garrett's deputies who was there the night the Kid was killed and cut it off, or even perhaps Garrett himself. It should be noted that John W. Poe refutes this in his book *The Death of Billy the Kid*, in which he states, "The story that we had cut off and carried away his fingers was even more absurd, as the thought of such an act never entered our minds." Also intriguing is a comment made by Josh Brent, son of one of Garrett's deputies, who said that Garrett told his father that after he killed Billy, he received a letter from back east from a man claiming he would pay $500 for the boy's trigger finger. More likely, as the interview was conducted in 1938, Brent was recollecting the "Fatal Finger" story from the *Optic* in some fashion.

An even more macabre story appeared in the *Optic* on September 10 entitled "The Kid Kidnapped":

The fifth day after the burial of the notorious young desperado, a fearless skelologist of this country, whose name, for substantial reasons, cannot be divulged, proceeded to Sumner, and in the silent watches of the night, with the assistance of a compadre, dug up the remains of the once mighty youth and carried them off in their wagon. The "stiff" was brought in to Las Vegas, arriving here at two o'clock in the morning, and was slipped quietly

17

into the private office of a practical "sawbones," who, by dint of diligent labor and careful watching to prevent detection, boiled and scraped the skin off the "plate" so as to secure the skull, which was seen by a reporter last evening. The body, or remains proper, was covered in dirt in the corral, where it will remain until decomposition shall have robbed the frame of its meat, when the body will be dug up again and the skeleton "fixed up"—hung together by wires and varnished with shellac to make it presentable. Then the physicians will feel that their labors have been rewarded, for the skeleton of a crack frontiersman does not grow on every bush, and the "bones" of such men as the Kid are hard to find. The skull is already "dressed," and is considered quite a relic in itself. The index finger of the right hand, it will be remembered, was presented to THE OPTIC at the time the exhumation was made. As this member has been sent east, the skeleton now in process of consummation will not be complete in its fingers; but the loss is so trivial that it will be hardly noticeable.

According to Fort Sumner resident Charles Foor, these newspaper articles caught the attention of Pat Garrett. A 1928 article in the *Southwestern Dispatch*

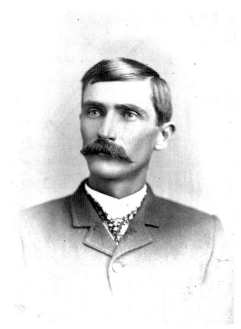

Sheriff Patrick Floyd Garrett, slayer of Billy the Kid, in a portrait taken in Las Vegas, New Mexico. *HSSNM, #1925.*

related that "Mr. For [*sic*] said that he had inspected the grave in the company of Pat Garrett 18 months after the internment [*sic*] and when the first claim of the moving of the bones was made by the Las Vegas people. At that time both men agreed that the grave was untouched."

One of Garrett's biographers, Richard O'Connor, claimed that Garrett visited the grave several weeks later after his "indignation was aroused by reports that carnivals, dime museums, and other opportunistic enterprises were displaying what they claimed where parts of Billy's corpse." O'Connor also claims that while there, Garrett even dug up the body to make sure,

The Maxwell House in a state of disrepair in its later years after the shooting of the Kid. *HSSNM, #1416.*

but this is doubtful.[1] Whatever the case, Garrett addresses the rumors in *Authentic Life*:

> *I said that the body was buried in the cemetery at Ft. Sumner. I wish to add that it is there today intact—skull, fingers, toes, bones, and every hair on the head that was buried with the body on that 15th of July, doctors, newspaper editors, and paragraphers to the contrary now withstanding. Some presuming swindlers have claimed to have the Kid's skull on exhibition, or one of his fingers, or some other portion of his body, and one medical gentleman has persuaded credulous idiots that he has all the bones strung up on wires… Again I say the Kid's body lies undisturbed in the grave—and I speak of what I know.*

The saga of Billy's body parts continued on September 19, when the *Optic* received a letter from a woman, Kate Tenney of Oakland, California, alleging to be the Kid's ex-lover requesting that she be given said trigger finger. The editor then replied to the woman that it had already been sold for $150. The editor went on to joke that perhaps the sawbones who had Billy's corpse from the September 10 story could send the poor girl "a shank bone—or something of that kind." While the *Optic* editor, Russell Kistler, is usually attributed to cooking up the letter, this story was actually run by another editor at the *Optic*, Lute Wilcox. The finger was supposedly sold to one Albert Kunz, who operated a drugstore in Las Vegas. Kistler

SKULLS OF A FEATHER FLOCK TOGETHER

The tale of Billy's stolen skull is in good company alongside that of Mexican revolutionary Pancho Villa and the Apache chief Geronimo, whose skulls were rumored to have been stolen and then used in ceremonies for the Skull and Bones Society at Yale. Villa's grave was vandalized and his skull stolen in 1926. A soldier of fortune and former ally turned enemy of Villa's, Emil Lewis Holmdahl, was accused of the crime. The elaborate motive for the theft was the rumor that Pancho Villa had a treasure map tattooed on the back of his scalp, and his corpse was still fresh enough after his 1923 assassination to decipher it. As for Geronimo's skull, some say it was stolen from the Fort Sill cemetery by Prescott W. Bush, grandfather of President George W. Bush, when he was stationed there. He then took it to Yale for use by the Skull and Bones Society.

wrote of Kunz's departure to Waterville, Kansas, and indeed the *Waterville Telegraph* reported on September 16 that "Mr. Albert Kunz returned home last Monday from Las Vegas. He is looking hale and hearty, and brought as a relic of barbarism a specimen of the physical existence of Billy the Kid."[5]

The *Optic* kept up its coverage of Billy's traveling finger in its October 14 issue, in which it was reported that it was now on display in Indiana at several county fairs. This was the last item to be reported on the finger's whereabouts, and it is presumed to be lost. Thanks to the "Fatal Finger" story, readership of the *Optic* soared, so other newspapers began to follow suit. In 1885, the *Silver City Enterprise* wrote a story on the Kid's skull being in the possession of an Albuquerque man.

THE FIRST OF MANY GRAVE MARKERS FOR BILLY THE KID

While Billy's bones were constantly under threat of being pillaged, his first grave marker, a crude wooden cross, also had several notable adventures. It was first "stolen" by none other than his alleged girlfriend, Paulita Maxwell.[6] Paulita and her brother Pete had a ten-dollar wager going that she would be too afraid to go out to Billy's grave at midnight. When Paulita agreed to make the short journey to the cemetery, Pete insisted that she bring back a weed or flower to prove she had

been there, but she brought back the entire cross to her doubting brother, to his utter shock. The next morning, Paulita sent one of the servants to put the cross back into the ground. Coincidentally, many years later, Paulita would be buried in this same cemetery.

Another story says the cross was stolen yet again to become a sort of shrine to the Kid's memory,[7] but this could be a bastardization of the Maxwell story. It would be remiss to not divulge that the Maxwell family actually had one of their servants fashion the cross to begin with on the day of the funeral. It was said to be made of a white fencepost about four feet tall from the fairgrounds that was sawed in half to make a cross, with the pointy end of the fencepost used to drive it into the ground. The cross had "Billy the Kid, July 14, 1881"[8] painted on it, and in the upper left-hand corner was inscribed in a lady's handwriting, "Dormir Bien Querido" (Sleep well, dear one).

It would seem that the Kid's grave marker was not long for this world, as some time after this, the wooden cross was nearly destroyed when a group of soldiers from Santa Fe used it as target practice in 1883. "Shot it plumb to kindling wood," said Charlie Foor, a contemporary of the Kid, in *Saga of Billy the Kid*. Colonel Jack Potter, who arrived in Fort Sumner in 1884, refutes this 1883 tale. According to him, the cross had only eight bullet holes in it when he saw it but was still standing. "I believe I am the only man living that really knows what became of that marker and the correct inscription on it," Potter said to historian Maurice G. Fulton. Potter was working for the New England Cattle Company, which now owned the property and had come down to inspect it around 1886. After their inspection was over and it was time to board a stagecoach and head back home, one of the easterners remarked, "We have forgotten something; we have not visited the Kid's grave." So Potter took them to the cemetery, which was in a bad shape. The gate had fallen down, and several cattle had wandered into the cemetery and were using some of the crosses to rub their necks on. Then the easterners laid their eyes upon Billy's pitiful cross and remarked, "This is our land, our cemetery and from the appearance and condition of this cemetery, it will all be destroyed in a short time. I'm going to take this marker back east and put it in a museum." And so Billy's first grave marker was strapped to the stagecoach with the rest of the luggage and headed east. Many years later, in the mid-1920s, Potter tried to ascertain if the cross ever really did get put in a museum as promised. Unfortunately, Potter was only able to trace Billy's cross as far as Las Vegas, New Mexico, via a stagecoach driver named John Roark, who stated in a letter to Potter that he saw the cross strapped "to a feller's luggage as he boarded a train back east."

According to Potter and others, the Kid's old cross was replaced with another to mark the spot, and according to Pat Garrett, who returned to inspect the grave in 1902, the new cross also had been shot full of holes. There in the company of western writer Emerson Hough, Garrett made a toast to his dead victims, stating, "Here's to the boys. If there is any other life, I hope they make better use of it than the one I put them out of." Garrett himself would be shot and killed only six years later, possibly taken by surprise just as much as the Kid was when Garrett shot him—as, according to some theories, Garrett was shot in the back while urinating.

A 1904 flood washed away the cross, along with the markers of other graves. The flood lasted for one week, and the waters were as deep as four feet in some spots. Along with the Kid were also buried about sixty soldiers, most of whom were killed in various Indian wars. Whether the marker was then put back on the right spot is unknown.

AN EMPTY COFFIN?

In 1906, Fort Sumner was abandoned as a military post, and as such, it was decided that all the soldiers buried in the Old Military Cemetery should be dug up and moved to the National Cemetery in Santa Fe.[9] Though not intentional, it's possible Billy and his two outlaw pals also made the trip to Santa Fe. An old-timer remarked, "Wouldn't it be ironic if those desperados now rest in Santa Fe as unknown soldiers with American flags over them?" Researcher Frederick Nolan tracked down one article that raises the possibility, unreliable though it may be. In the June 2, 1955 *El Crepusculo* out of Taos, reporter Kelly Rae Hearn wrote that a Catholic priest by the name of Father Burke oversaw the exhumation of the soldiers' graves and that when it was all over, "the grave formerly occupied by the body of the Kid was empty."[10] As another interesting aside, a story exists in *An Outlaw Called Kidd* by Zeke Castro regarding a time when the "supposed coffin of the Kidd was moved because water was eroding the ground around it." Inside this coffin were nothing but a saddlebag and some rocks. The story comes from a man named Alfred Hale,[11] who told the story to Severo Gallegos Jr., who told A.B. Munsey, who then told Castro.[12] This is similar to a story related by J. Frank Dobie that the Kid's coffin contained "three bags of sand" in *Apache Gold and Yaqui Silver*. A 1980 article by Ben W. Kemp in the *Frontier Times* features a quote from John Graham, who allegedly dug the Kid's grave in Fort Sumner.

He claims that once the casket arrived via wagon for burial, it was accompanied by an armed guard to make sure no one opened it to see "what" was inside. Yet another story told by Verna Reed of Carlsbad, who said her uncle Joseph Wood helped dig the grave, claims the side of beef Billy went to cut a slice off of before he "died" was what was buried in the casket.[13] Stranger still, an old weathered newspaper clipping dated December 3, 1925, runs the headline "Billy the Kid's Bones as Elusive as Bandit." Only this strange story relates how a "Lincoln party had excavated the supposed site of burial, and found neither coffin, or bones, or anything but earth." However, this same article also states, "The body was supposed to have been buried near Lincoln, N.M., the site being well known." No wonder the diggers found nothing but earth.

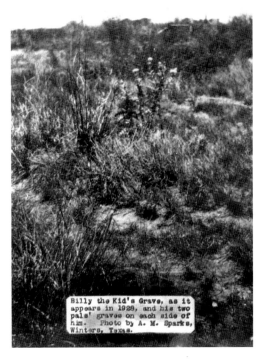

The Kid's unmarked grave as it appeared in 1928. *Western History Collections, University of Oklahoma Libraries, Rose Collection, #2175.*

A TOMBSTONE FOR BILLY

After the loss of Billy's marker in the flood, the grave remained unmarked for many years. Luckily, old-timer Charles Foor (born in 1850) visited the grave regularly and knew where the Kid was buried. Foor took Walter Noble Burns to the spot when he came to Fort Sumner to research his book. The cemetery was in a poor state at the time, as the adobe walls that once encompassed it had long since fallen down and it was now bordered by a barbed-wire fence.

"The place you might say was a decent spot for dead men to sleep in," Foor is quoted as saying and continues that while once the cemetery looked

like holy ground, it now went by the name of Hell's Half Acre for all the men who "died with their boots on"—twelve in all, counting the Kid. Ironically, Billy is buried in the same yard as one of his victims, Joe Grant, who he killed in Jose Valdez's saloon.

After Burns's book became an overnight sensation, Fort Sumner finally placed a metal marker in a random spot of the cemetery for tourists. It was described as a "fairly dignified octagonal marker, suitably inscribed with Billy the Kid's name and a few of the facts and dates concerning him" in an old article by writer H.S. Hunter. The article goes on to relate how a broken bit of shovel blade sits at the head of one of the other graves, either O'Folliard's or Bowdre's, and nothing at all at the other. However, some also thought that the shovel marked Billy's grave. For several years, old-timers like Foor and friends of the Kid like George Coe petitioned for a proper marker to be created. Finally in 1930, a headstone was created for all three "knights of the six shooter," as the exact spot for all three was uncertain. Ironically, prior to the 1930 creation of the marker, Foor said in *Saga* that "there was some talk of erectin' a monument over the Kid's grave. Somebody tried to start a public subscription. But people in New Mexico seemed scandalized. 'Why, he killed twenty one men,' they said. 'Contribute to a monument for such a terrible desperado? Not on your life.'"

Apparently it was a different story among the "art colony" folks in Santa Fe and Taos, whom at some point tried to raise money to erect a statue over the Kid's grave as a sort of shrine. This took place a few years after the death of Pat Garrett in 1908, which greatly upset his daughter, Elizabeth Garrett. She brought the matter before one of her father's former deputies, James Brent, who wrote the legislature and put a stop to it.

Odder still, a similar argument took place in Fort Worth, Texas, in 1926 as to whether to erect a monument to the Kid there.[14] As the Kid was a frequent visitor to Texas, notably the town of Tascosa, there was a movement by some to erect some sort of marker to his memory. It was shot down by the United Confederate Veterans, a member of which stated, "There is no monument in Ft. Worth to the memory of the men who fought in rags and tatters for the Confederacy. Why should one be erected to a man who killed for the love of killing, 21 men in as many years?"[15]

When the monument was finally placed in the Fort Sumner cemetery in 1930 with the help of three of Billy the Kid's surviving pallbearers, all of whom could not agree on an exact location, it was placed in the middle of the three's guesses. Though the DeBaca County Chamber of Commerce is credited with the stone's creation, rumors exist that movie producer King

Vidor footed the bill to coincide with his film *Billy the Kid*, based on Burns's book. The new marker was molested within only months of its placement as tourists began chipping off pieces of it one by one. One legend even purported that there was now a mark on the tombstone for "each of the men he murdered."[16] Worse still, in 1938, Billy's plot was almost plowed up. The incident occurred when the cemetery was sold to "a private individual for back taxes."[17] Soon after the purchase, a ditch was plowed dangerously close to Billy's plot. Fort Sumner residents became very upset, and legal action was taken to protect the grave.

In 1940, a footstone just for Billy was placed on the plot. It carries an inscription that reads "Truth and History," but in reality, it promotes several famous myths of the Kid, including his incorrect November 23, 1859 birthdate and a reference to the twenty-one men he killed. Poetically, it also reads, "The Boy Bandit King. He died as he had lived." A 1994 edition of the *Tarelton Texan Weekly News* claims that the footstone was a prop[18] used in *The Outlaw*, released in 1943 (but filmed years earlier), and the prop was then donated to the cemetery. However, a Mrs. George Mitchell of Albuquerque claims it was made by her father, J.N. Warner, who did so after learning the Kid had no marker to himself. At his own expense, he made it from his own granite quarry in Colorado and drove it to Fort Sumner himself along with his family.[19]

At some point in the 1940s, a chain-link fence was placed around the plot to stop tourists from chipping off portions of the bigger tombstone for all three outlaws. On August 29, 1950, the footstone was stolen and would remain missing for a quarter of a century.

Billy wasn't the only Lincoln County War veteran to have his tombstone stolen. This also happened to the original headstone of Yginio Salazar, Billy's *companero* who famously played dead outside the McSween house. Salazar's original grave marker was a stone from the Salazar ranch with his picture glued to it. After it was stolen, it was replaced with a larger marker that stated, "Pal of Billy the Kid." Also stolen were the tombstones of Sheriff William Brady and George Hindman.

In 1962, more controversy arose when there was talk of having Billy reburied in old Lincoln Town. The request was said to be filed by New Yorker Lois Telfer, a descendant of Celinda Bonney, who claimed to be a first cousin to the Kid, though other sources infer the Town of Lincoln called for the "return" of the remains first. An editorial of the time by Paul Baker stated, "The Lincoln County Board of Commissioners is to be commended for the action taken last Friday in passing a resolution calling for the removal

of the remains of Billy the Kid to their rightful resting place at Lincoln town in Lincoln County." The article argues that Lincoln was really Billy's home, and he would be interred in a fully landscaped "Billy the Kid Park" that would have "a dignified setting, entirely away from outlandish advertising on highway signs,"[20] though that this park would somehow have more dignity than his proper burial plot is highly unlikely under the circumstances. The lawyer at the head of the effort was none other than Alamogordo attorney C.C. Chase Jr., a grandson of the notorious Albert B. Fall, an on-again-off-again political enemy of Pat Garrett's. In the end, a New Mexico court district judge wisely refused the request, to Fort Sumner's relief, with some help from one of Charlie Bowdre's distant relatives, Louis Bowdre, who protested the effort lest it disturb his relative's remains.

RETURN OF THE OUTLAW
BILLY THE KID'S TOMBSTONE

Finally in the summer of 1976, Billy's missing footstone was returned to Fort Sumner. The mystery was partially solved by Sophie Essinger, a clerk at the Old Fort Sumner Museum, which houses the cemetery on its grounds, in July 1975. Two Granbury, Texas residents, Mr. and Mrs. Branham, visiting the museum read up on the missing tombstone and then told Essinger a remarkable story. Back in 1969, Mr. Graham had sold some property outside Granbury to a Mr. Gaylan Wright, who moved a boxcar off the property and in the process discovered the tombstone underneath it. He showed the Branhams, and there it continued to lie for the next seven years until they invited Essinger to come out to Granbury to see it. She diligently tracked down the tombstone and snapped a picture of it, which she then gave to Fort Sumner sheriff Earl Turnbow. Turnbow, in turn, contacted the sheriff of Granbury, who brought the tombstone back home to Fort Sumner just in time for the annual Old Fort Days in May 1976. Granbury is an odd place for the tombstone to turn up, as it was the home of both a John Wilkes Booth impersonator and also the burial site of Jesse James claimant J. Frank Dalton, himself a friend of Billy the Kid claimant Brushy Bill Roberts. It's fascinating to note that Roberts visited Billy's grave shortly before the footstone was stolen on July 6, 1950. Though it's tempting to speculate the two incidents are related, the owner of the Billy the Kid Museum, Tim Sweet, claims to have received an anonymous e-mail in recent years from a

The footstone arrives at the cemetery via a hearse driven by undertaker Eloy Martin and Boots Sutherland. *New Mexico Department of Development.*

woman who claimed her uncle was the one who stole the tombstone. "He got scared and just threw it out in a field."[21]

Only five years after its return, the tombstone was stolen again in February 1981. The February 2, 1981 *Roswell Daily Record* proclaimed, "The Kid's Tombstone Vanishes in Daylight." However, this time it took only a little over one week to track down the tombstone. The prime suspect in the second tombstone caper was an unnamed truck driver who regularly traveled between Tulsa, Oklahoma, and Huntington Beach, California. Governor Bruce King sent De Baca County sheriff "Big John" McBride all the way to California to pick it up and transport it back to New Mexico. It was formally placed back at the grave site to great fanfare (even Jarvis Garrett was there) on May 30, 1981. The next year, the marker was anchored down with iron shackles, and a large steel cage was placed around the entire plot. Some whispered the whole episode was staged to generate more publicity for the 100th anniversary of Billy's death.

In the late 1980s, when Hico, Texas, home of Brushy Bill Roberts, began to put on its own Billy the Kid events, Fort Sumner residents feared that perhaps the tombstone would be stolen yet again. So members of the Billy

the Kid Outlaw Gang stood guard in front of the grave, complete with rifles and shotguns. Among the guards were Janean Grissom, Frank Chino Silva, Joe Bowlin and Jeff Wooten.

Today the thefts continue—not of the tombstones but of city signage. Allen Sparks, head of the Fort Sumner Community Development Corp, said in the *New Mexican*, "Anything that has to do with Billy the Kid periodically gets stolen. If it says 'Billy the Kid' and it can move, it'll go." Another historical plaque near Stinking Springs has now been stolen so many times that the New Mexico government no longer bothers to replace it.

Fort Sumner has made light of the thefts with the creation of the Billy the Kid Tombstone Race, held annually each June. In the event, male contestants must run an obstacle course carrying an eighty-pound tombstone replica, while the women compete with a twenty-pound version.

BILLY RIDES AGAIN IN RAMAH

JOHN MILLER'S STRANGE STORY

When a man comes back from the dead, he runs into a good many difficulties.
—*C.L. Sonnichsen and William Morrison,* Alias Billy the Kid

It would seem that pretending to be a dead historical icon from the Old West was a popular pastime during the early twentieth century. Among those said to have survived their alleged demises are Jesse James, Butch Cassidy, Davy Crocket, Albert Jennings Fountain[22] and John Wilkes Booth, to count only a handful. In essence, any western figure worth his salt had someone pop up after his death claiming to be him. However, Billy the Kid had more than one, and for a time, John Miller was the best known of these imposters—until Brushy Bill Roberts came onto the scene in the 1940s.

The story of John Miller is appropriately fairy tale–like and hinges somewhat upon the romantic notion that Pat Garrett and the Kid were friends. In this version, Garrett killed a Mexican youth, passed him off as the Kid and then warned the real Kid and his girlfriend to get out of town. Even Billy's girlfriend is someone famous in this story, as she is speculated to be none other than Charlie Bowdre's widow, Manuela, going under the new alias of Isadora.

Naturally, there are conflicting versions of Miller's story. One says he was injured in a shootout several days before the historical Billy was shot on July 14, 1881. As Miller lay recuperating with Manuela/Isadora, Pat Garrett shot an Indian man dressed like the Kid and passed him off as the outlaw. Yet another variation of the shooting is recorded by Gary Tietjen in his book

Encounter with the Frontier. It goes that after Garrett shot the Kid, the body was taken to some Mexican girls to be prepared for burial. When the girls found the body to be still breathing, they took the Kid to a woman named Isadora to be nursed back to health in secret. Once the Kid recovered, he left Lincoln County for good. A body of a recently deceased Mexican man was buried in Billy's place, unbeknownst to Pat Garrett.

The Kid and Isadora then rode out of town a few days later heading for Las Vegas, New Mexico. This in itself is an odd choice, as Billy the Kid was a favorite topic of the *Las Vegas Optic* and, therefore, it is not the place he would go to lay low. Nonetheless, the Kid, now under the name of John Miller, married Isadora in a ceremony overseen by a parish priest named Father Berrera. Under the cover of darkness, they traveled to Mogollon, where Miller worked for a time at the Nation's Ranch. There, Miller allegedly shot a Hispanic man who mistreated Miller's horses. After the shooting, they headed north toward the Ramah area near the Zuni Pueblo. At first Miller

Illustration of the Kid's vigil by William Ford in *Little Known Facts About Billy, the Kid* published in 1964. *Author's collection.*

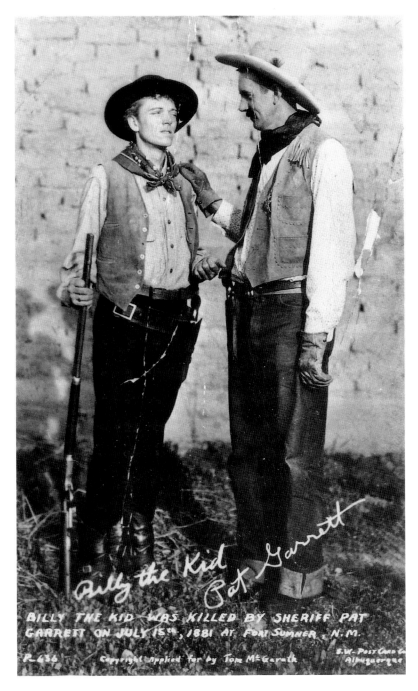

Actors pose as Billy the Kid and Pat Garrett in friendly conversation in this vintage postcard. *HSSNM, #5203.*

hid out in the caves and Isadora would bring him food. Eventually, Miller befriended Jesus Eriacho, a future governor of the Zuni people, and Eriacho made a deal with Miller to watch his cattle; in return, he would give Miller a share of the calves born in the spring. And thus, Billy the Kid became a peaceful rancher. Eventually, Miller and Isadora even adopted a two-year-old Navajo boy named Max.

Miller soon endeared himself to his neighbors in the area, all of whom loved him, and in later years claimed that he was Billy the Kid. While future claimant Brushy Bill could actually tell fairly accurate tales of the Lincoln County War, Miller told close to none. He only looked like Billy the Kid and implied to people that he was one and the same. Examples included Miller delighting children by doing tricks for them, such as tying his wrist into a tight rope and then slipping it free, quipping, "Billy the Kid could do that." When a neighbor once read excerpts from a book on Billy the Kid to Miller, he became agitated and angry, stating, "That's a damn lie."[23] Frank Creasy, a cowhand on the Miller ranch, claims Miller told him he shot a man for insulting his mother when he was twelve—a common dime novel tale. Among the more adventurous stories Miller told was that he was part of a bank heist along with six others in Montana in 1902. The bandits stole $8,000 and split it, hiding $4,000 in two separate spots. Miller was wounded while running from the posse and received a bad bullet wound to his side that had to be cauterized with a branding iron. Miller was caught and stood trial and then bought himself a pardon with the very money he stole. Or so Miller said, and allegedly this pardon hung framed in his ranch house.

Supposedly a trunk of Miller's belongings existed that "proved" he was the Kid. It contained old photographs of himself, a gun with twenty-one notches carved in it, a slug he dug out of his body with a knife and even a jar of old gold coins, among the more interesting items. It was presumed lost in a fire in Arizona that also killed Isadora.

Adding to the "proof" that Miller was really Billy is the fact that Miller and Isadora would only travel at night, taking the back roads, lest anyone should recognize John. These trips were often to El Paso, which is interesting because of an alleged Billy the Kid sighting in Las Cruces in the 1920s. Some even speculated that he could be visiting his old friend Pat Garrett—depending on which version of the Fort Sumner shooting one was going by—as Garrett was the customs collector in El Paso from 1901 to 1905. Miller himself said he and Pat Garrett were good friends and a Mexican man was buried in his place.

Adopted son Max, who was known among the Navajo people as "Billy the Kid's Son," wasn't shy about telling anyone his father's secret. As a young soldier at Fort Wingate, someone hung a picture of Billy the Kid on the wall and asked if Max knew who it was. He simply responded, "Yes, that's my dad."

The Millers, both of whom were becoming decrepit due to the hard frontier life, were devastated when they learned that their son Max was missing in action in Germany during World War I. It was 1918, and they decided to leave Ramah for San Simon, Arizona, near the Mexican border. The Millers eventually received a surprise visit from Max, who, like his father, was only presumed dead and had returned home safely. By 1920, the couple was living in Buckeye, where John worked as a horse trainer.

In early 1937, Miller was admitted into the Prescott, Arizona Pioneers Home. There, as his health failed, he sent word to several old friends to come see him so he could set the record straight on his mysterious past. Instead, Miller passed away on November 7, 1937, with no one there to record what could have been a real whopper. He was buried in the Pioneer Home Cemetery, where also lies the founder of Roswell, Van C. Smith.

Miller, unlike future claimant Brushy Bill Roberts, was disinterred (some say illegally) from his grave on May 19, 2005, as part of a Lincoln County Sheriff's Department investigation into Billy the Kid. Miller's DNA was then to be compared to blood found on a slab that Billy was allegedly placed on after being shot. As it turned out, no DNA was even able to be extracted from Miller's bones, so DNA extracted from a corpse buried next to Miller was tested against the DNA on the bench instead. In effect, it was all just a media circus and quite a scandal, dubbed "Shovelgate" by Gale Cooper in her book on the subject, *Mega Hoax*.

THE TWO LIVES OF BRUSHY BILL ROBERTS

Regardless of which position a researcher assumes on the matter, absolute proof of what actually occurred that night in 1881, what transpired to the days leading up to it, and the subsequent inquest and burial does not exist.
—*W.C. Jameson,* Billy the Kid: Beyond the Grave

Though he wasn't the first, or even the second, claimant to the "Boy Bandit King's" throne, the most prominent of them all is O.L. "Brushy Bill" Roberts of Hico, Texas.

The case of Brushy Bill begins in Florida, where a paralegal investigator from Missouri, William V. Morrison, was looking into the insurance claims of a man named Joe Hines in 1948. Morrison learned part of the reason Hines was having trouble processing his claim was that Hines was just an alias he used to cover up his real identity as a former fighter in the Lincoln County War (some believe him to have been outlaw Jesse Evans). Upon learning this, Morrison told the man of his own family connection to the Lincoln County War in the form of a great-grandfather, Ferdinand Maxwell. This Maxwell was the brother of the famed landowner Lucien Maxwell (buried in the same cemetery as the Kid) and the uncle of Pete and Paulita (the latter the Kid's alleged girlfriend and the former in whose presence Billy was shot by Garrett). At this point, Hines began regaling Morrison with tales of the war and then let slip that Billy the Kid never was shot by Pat Garrett and was still alive today in a small Texas town, the name of which he couldn't recall. As fate would have it, another long-dead outlaw—J. Frank Dalton, who

claimed to be Jesse James—resurfaced in Morrison's home state of Missouri. Morrison contacted Dalton, who knew of the man of whom Hines spoke and gave Morrison the name and address where this man could be found (how the two undead desperados kept in touch is something of a mystery). By June 1948, Morrison was in Hamilton, Texas, on the doorstep of O.L. "Brushy Bill" Roberts, who answered the door clad in a cut-off sweatshirt and jeans. The ninety-something-year-old man certainly looked like he could pass for an elderly Billy. Among his physical similarities were large wrists ending in small hands, large ears and blue-gray eyes. When Morrison, after some polite conversation inside with Roberts and his wife, asked Roberts about him being the famed outlaw, the man became red with embarrassment and said that no, he wasn't the Kid, he was only his half brother and that the Kid was currently residing in Mexico. As it turned out, and Morrison learned at a second arranged meeting, the old man really was the Kid and merely didn't want his wife in the other room to overhear their conversation.

At this point, Roberts began to reveal his secret history as William Henry Roberts (O.L. Roberts was an alias acquired from a dead relative, he said), born in Buffalo Gap, Texas, on New Year's Eve 1859. Roberts's parents were Mary Adeline and James Henry Roberts, who left Texas soon after to fight in the Civil War. For those wondering how the Kid's historical mother, Katherine Bonney, comes into play, Roberts explains that she was his mother's half sister who took him in after his own mother died. The widowed Mrs. Bonney took young Roberts with her to Trinidad, Colorado, and later Santa Fe, New Mexico, where she married William Antrim, Billy's infamous stepfather. While there, Roberts (now known as Billy Antrim) befriended a future frenemy of his: Jesse Evans.[24] Eventually, young Roberts grew restless and set out to find his birth father, who had by then returned to Texas. Roberts reunited with his father, who taught his son the art of breaking cattle and sharpshooting. Fifteen by this time, "Kid" Roberts, as he was now called, was more than proficient with a rifle and a handgun. When he was old enough, Roberts traveled to Oklahoma to try his hand at cattle. While there, he made the acquaintance of Belle Reed, who would later become Belle Star, known by some as the Bandit Queen who helped organize and aid in cattle rustling. Among the company Reed kept on her ranch were the Younger brothers and Jesse and Frank James. It was the first of several times that Billy the Kid may have met up with one of the James brothers. Roberts served as the lookout on Reed's ranch at the time, and judging from Roberts's stories, it would seem Reed was something of a mother figure for him. Eventually, Reed dubbed him the "Texas Kid" and

gifted Roberts a set of new clothes and fifty dollars when the duo parted ways. This is when Roberts returned to Silver City just in time for the death of his aunt Katherine Antrim in September 1874.

After this, Roberts (now alias Billy Bonney) headed for Dodge City, Oklahoma, and also passed through South Dakota, Wyoming, Nebraska, Montana and Arizona by his own account. It's worth noting that in 1877, Roberts reunited with Jesse Evans in Arizona, where Evans had assembled an outlaw gang consisting of Billy Morton and Frank Baker, among others.

This eventually led Roberts to Lincoln by way of the Jones Ranch at Seven Rivers, New Mexico. Through the Joneses, Billy Bonney (or rather, this version of Billy Bonney) began working for John Chisum in Roswell, and the rest, as they say, is history...depending on who's telling it. From this point forward, Roberts's account doesn't deviate too far from the historical Lincoln County War, give or take a few details. Naturally, it is only at the point of the night in Fort Sumner and his confrontation with Pat Garrett where the story deviates.

As for Roberts's spin on the infamous friend or foe relationship between the Kid and Garrett, Roberts said he already knew Garrett from their mutual time together in Texas, where Garrett had been a buffalo hunter. Roberts claimed that he and his friends bought the "penniless" Garrett some new boots and even paid for his wedding reception upon coming to Lincoln. As far as other socializing went, Roberts called Garrett "one of the boys" and recalled gambling with him and seeing him at dances and other social functions. Obviously, the two weren't very good friends, as Garrett betrayed Roberts when he swore to hunt him down after being elected sheriff. Roberts returned the sentiment by vowing to kill Garrett. As in real history, the two collided in Fort Sumner on July 14, 1881. The most important player in Roberts's tale is that of his patsy, a friend of his named Billy Barlow.[25] The man called Barlow (believed to be an alias) arrived in Lincoln County in 1880, having met Roberts while at the Muleshoe Ranch in Texas. Conveniently, young Barlow was about the same age and of similar appearance to the Kid. On July 14, he was accompanying Roberts, Celsa Gutierrez and another woman to a dance. After returning to the home of Jesus Silva, a fateful discussion began involving the lack of fresh meat for a late-night snack. Only in Roberts's version of the tale, he didn't set out into the night to go and cut some meat from a steer at nearby Pete Maxwell's house—Billy Barlow did.

Within minutes, Roberts and Silva heard gunshots and assumed they came from Garrett, whom they knew to be in town looking for him. Rushing outside, guns ablaze, Roberts began firing at shadowy figures he glimpsed at

Maxwell's house. In the gunfire, Roberts was hit three times, first in his lower jaw, taking out a tooth as it passed through his mouth; next on the shoulder; and lastly another that skimmed the top of his head. Roberts stumbled into the home of a lone Mexican woman who knew him and passed out. She tended to Roberts's wounds, and when he awoke, Celsa Gutierrez entered with good news: Pat Garrett was passing off the dead Billy Barlow as Billy the Kid. Though Roberts wished to go and take revenge on Garrett, Celsa convinced him to leave town. So at 3:00 a.m. that morning, Roberts and a friend, Frank Lobato,[26] drifted out of town. Roberts and Lobato slowly made their way to Mexico, specifically Sonora, where Roberts would live in a Yaqui Indian village for two years.

THE SAGA OF BILLY THE KID, PART II

It's too bad Walter Noble Burns wasn't alive to interview Roberts when he rose to prominence in the 1940s. If he had been, between Roberts's and his own embellishments, he would've likely run out of ink writing *The Saga of Billy the Kid, Part II*. As it turns out, or at least according to Roberts, Billy's life after his "death" was even more interesting than his real life. Among his numerous adventures were participating in Buffalo Bill's Wild West Show, aiding Pancho Villa during the revolution and even joining up with the Pinkerton Detective Agency.

It was also in this second phase of his life, post death, that he gained his new nickname, "Brushy Bill." It was in the winter of 1884, when he was working as a scout and stage-line guard in the brushy hill country, that he was given his new name. Not long after this, Brushy Bill was in Nebraska working for Buffalo Bill Cody in his Wild West Show. In 1888, Roberts joined the Pinkerton Detective Agency for a short stint, and after that, he was in the Anti–Horse Thief Association, going under the new name of the Hugo Kid. Next up was a stint working as a deputy for the "Hanging Judge" Isaac C. Parker, who had previously sentenced his old friend Bell Starr to prison for horse theft. By 1890, Roberts had even endured a tenure as a failed boxer.

Brushy Bill's next great adventure came in 1892, when he was a U.S. deputy marshal investigating train holdups. Whilst trying to stop a live train holdup, he discovered the perpetrators were none other than the famous Dalton gang. As such, some of their members recognized him as Billy the Kid from his days hanging out with the Younger brothers, to whom the

Dalton gang was related, and let him live. The members of the Dalton gang, on the other hand, weren't long for this world and met their demise the same year. Roberts also claimed to be part of the U.S. marshal's group that apprehended Chitto Harjo, better known as the Native American revolutionary Crazy Snake. Brushy Bill went back to breaking horses, which led him to a new job all the way on the Shetland Islands off the coast of Scotland, where he caught wild horses. After three months, Roberts was back in America with the Anti–Horse Thief Association again when he stumbled across a dead body—and not just any corpse, but the body of his deceased relative O.L. Roberts. Always one to seize the moment, Roberts picked up the dead man's identification and soon began to pass himself off as O.L. Roberts, though this name would later come back to haunt him as to the legitimacy of his Billy the Kid claims (since later O.L. Roberts would be confused with an Oliver P. Roberts, a cousin, born in 1879). The next few years were spent riding in Buffalo Bill and Pawnee Bill's Wild West Shows and then ranching in Mexico up until 1897. In 1898, Roberts set out to join President Theodore Roosevelt's Rough Riders. It's a good thing he never ran into Pat Garrett, who would also rub elbows with Roosevelt and the Rough Riders from 1901 to 1905. Roberts was sent via the Rough Riders to Cuba, where he handled the horses of the regiment, which made the other enlisted men jealous. When three of these same men were later shot in the back during a fight with Cuban forces, Roberts and three other men were blamed for the deaths and subsequently court-martialed. No one was ever convicted, and Roberts was shipped back to the United States.

Still, Roberts's adventures didn't end there. Next up was a gun battle in Mexico when President Diaz seized Roberts's ranch in Chihuahua. Roberts and his partners battled the Mexican soldiers sent to seize the livestock in an intense battle that claimed twelve of the soldiers; Roberts survived but was badly injured. Eventually, reinforcements in the form of a one-thousand-man troop soon arrived to surround the ranch, with Roberts and his men fighting their way out and escaping into the desert. Pursued by the Mexican army the entire time, they finally passed the Rio Grande into Texas after thirteen hard days.

In 1902, Roberts took a page from the two Bills and began running his own Wild West show, which lasted two years. He was also said to be a performer in the "Booger Red" Wild West Show. As a humorous aside, one of Roberts's fellow performers, Jack Lewis, tried to bestow upon him a new nickname: "We tried to give Bill a nickname, 'ticklebritches'—but he wouldn't have it. Made us call him Brushy Bill. He was a guy we couldn't fool around with."[27]

TALL TALES AND HALF TRUTHS OF BILLY THE KID

By 1907, Roberts had returned to Mexico just in time for the revolution, which broke out only three years after he purchased a new ranch called the Three Bar. Roberts enlisted to fight alongside Venustiano Carranza and then signed on with Pancho Villa. After all, a story about Billy the Kid in the Mexican revolution wouldn't be complete without a run-in with Villa. Details of the two's relationship are sparse, but Roberts claimed that Villa used horses from Roberts's ranch in his cavalry. "I was captain of 106 men, all mounted on steeldust horses from our ranch," Roberts said.[28] Supposedly, Villa even gave Roberts a photograph of himself with General Ortega and Colonel Medina.[29] The Mexican revolution, as it turned out, would be Brushy Bill's last hurrah. After this, he returned to the States and finally settled down, marrying none other than Mollie Brown. After all of Roberts's claims thus far, one would probably think this is the same "Unsinkable Molly Brown" of *Titanic* fame. But this was a different Mollie Brown, albeit still from a prominent, wealthy family. Brown died in 1919, and in 1925, Roberts married Louticia Ballard. Roberts was widowed for a second time when Ballard passed away in 1944, but he wasted no time in finding wife number three, Melinda Allison, to whom he apparently never told his secret past.

This long history was related to William V. Morrison over the course of several days during a road trip the two took together to New Mexico in August 1948. While in New Mexico, the two stopped in Lincoln, where Roberts toured the old courthouse, the site of his most famed escape, and noted the many changes to the building since, most of which were accurate. Before the road trip, Roberts had made a request of Morrison to help him get a pardon for past crimes. Roberts claimed that he feared he was still under the death sentence for the killing of Sheriff Brady all those years ago, so much so that he broke down sobbing in Morrison's presence. His poetic words to Morrison were:

> *I done wrong like everyone else did in those days. I have lived a good life since I left New Mexico. I have been a useful citizen. I want to die a free man. I do not want to die like Garrett and the rest of them, by the gun. I have been hiding so long and they have been telling so many lies about me that I want to get everything straightened out before I die. I can do it with some help. The good Lord left me here for a purpose and I know why He did. Now will you help me out of this mess?*

Morrison then agreed to help Roberts seek a pardon from the current governor of New Mexico, Thomas Mabry. However, working up the

Coroner's Report, Reward Payment Proof Sought In Billy The Kid's Death By Lawyer

By BILL LATHAM
Times Managing Editor

Folks who read Daniel A. Storm's article in The Times about the annual "Billy the Kid" pageant up in Lincoln next Sunday should be interested in something that recently appeared in The Times.

On July 13 the Associated Press carried a story out of Carlsbad that a St. Louis lawyer, William V. Morrison, was investigating the death of Billy the Kid on behalf of an old man who might be the Kid himself.

Old timers who have lived in the Southwest have heard many times that Billy the Kid was not killed by Pat Garrett in Fort Sumner, N. M., in July, 1881. It is a story that never dies.

But Morrison, a lawyer, is seeking proof NOT that Billy the Kid is alive but that he was killed. Not hearsay proof, either, but proof that will stand up in court.

Morrison stayed in El Paso for some months and contacted many El Pasoans, including Dr. C. L. Sonnichsen of Texas Western College, Mrs. Helen Seymour Farrington at El Paso Public Library and myself. These in El Paso gave him names of others who could be checked.

Morrison argues that two convincing items of the proof of the Kid's death are missing. These are (1) the coroner's report which concerned the death and (2) the fact that the reward offered to any man who killed the Kid was not paid to Pat Garrett.

CORONER'S REPORT

Let's take up the coroner's report first.

In a story written by Mrs. L. A. Cardwell of Las Cruces and published in The Times on June 27, 1948, this coroner's report is mentioned. The article read, in part:

"(Pat) Garrett, in making his report to the governor of the Terri-

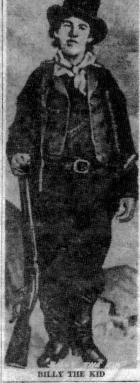

BILLY THE KID

tory of New Mexico, wrote:

"I hereby annex a copy of the verdict rendered by the jury called in by the justice of the peace (ex officio coroner), the original of which is in the hands of the prosecuting attorney of the First Judicial District. (The verdict is given in Spanish, in Garrett's report, translated as follows:)

"We the jury unanimously say that William Bonney came to his death from a wound in the breast in the region of the heart, fired from a pistol in the hands of Pat Garrett, and our decision is that the action of the said Garrett was justifiable homicide and are united in the opinion that the gratitude of all the community is due to said Garrett for his action, and that he deserves to be compensated.

"Signed: M. Rudolph, foreman; Antonio Saavedra, Pedro Lucero, Jose Silva, Sabal Gutierrez, Lorenzo Jaramillo."

Does anyone know where this original coroner's report is or where an authentic copy can be found?

WAS REWARD PAID?

Now about the payment of the reward money.

Apparently there was a $5000 reward offered for the capture or killing of the Kid.

In 1926 quite a bit of excitement was caused when someone "revealed" that the Kid was still alive. Files of the old Herald and The Times reveal a number of stories at that time.

In one, Leland V. Gardiner, identified as a Santa Fe officer, said: "One thing that leads me to believe that the Kid still lives, from what I have read, there was a big standing reward for Billy the Kid and Sheriff Pat Garrett did not collect the reward after he was supposed to have killed the Kid at Socorro."

Another clipping, about that same time, in 1926, says this:

"George Coe, of Glencoe, a side

(Continued on Page 3, Col. 4)

An article from 1950 detailing the then current exploits of William V. Morrison and O.L. "Brushy Bill" Roberts to obtain a pardon. *HSSNM.*

legalities of this petition took a good two years, and it wasn't filed until November 15, 1950. Earlier that summer, Roberts and Morrison had trekked across the Southwest, obtaining signed affidavits from people who recognized Brushy Bill as Billy the Kid. Examples included the widow of Roberts's Lincoln County comrade John Able, whom Roberts visited in El Paso. The elderly bedridden Martile Able claimed she had no doubt Roberts was the Kid, whom she miraculously recognized despite not having seen the Kid since before Garrett shot him. Then there was the written

testimony of Severo Gallegos, who claimed he saw Billy up close in person and spoke with him after his Lincoln courthouse escape in April 1881. Of Roberts, Gallegos said to Morrison, "Your man talks like Billy; he looks like Billy; he has small hands and large wrists, small feet, large ears, stands and walks like Billy; but he is not old enough to be Billy." However, at a later meeting between Gallegos and Roberts, Gallegos looked closely at the old man's face and stated, "That is Billy the Kid, all right. Only Billy had eyes like that." Jose B. Montoya, who knew the Kid when he was a child, swore to have seen and talked to the Kid after his death at a bullfight in Juarez in 1902. Much like Roberts, the Kid was dressed in a buckskin jacket. Montoya met with Morrison and Roberts in Carrizozo, New Mexico, on July 3, 1950, and said Roberts was the same man.

The petition was prepared by lawyers from the law firm of Andress, Lipscomb and Peticolas. Governor Mabry agreed to meet privately with Morrison and Roberts in Santa Fe on November 29. The meeting turned out to be an unmitigated disaster for Roberts, who was ambushed by the press and, in the excitement, could barely stutter out a few words. Roberts left Santa Fe in shame, as the skeptics doubted his claim—including Mabry, who granted him no pardon. The stress of the ordeal left old man Roberts bedridden for three weeks in Hico, Texas. On December 27, 1950, Roberts was feeling well enough to walk to the post office to deliver some letters for his wife. He made it there but not back home, as he had a fatal heart attack outside the post office.

After the old man's death, Morrison didn't cease his quest

BRUSHY BILL AND BUFFALO BILL CODY

Though Billy the Kid was occasionally portrayed as a sworn enemy of Buffalo Bill Cody in dime novels, in the "real life" of Brushy Bill Roberts, the two were pals. A signed affidavit by Robert E. Lee, one of the performers in Buffalo Bill's shows, claimed that Roberts was part of the show, that Lee knew him personally and that Buffalo Bill had been friends with Roberts's parents. Allegedly, Buffalo Bill fought Indians with Roberts's father, James Henry Roberts. It further stated that Buffalo Bill hired Brushy Bill Roberts to help him go straight. Apparently, Roberts never told Cody of his hidden history, for in the late 1930s, Cody's partner, Pawnee Bill, was out to disprove the fact that Billy the Kid was still alive.

to prove that Roberts was the Kid and teamed with noted historian C.L. Sonnichsen to author a book on his claims. It was published in 1955 as *Alias Billy the Kid*. Despite the assistance of the much-respected Sonnichsen, in the end Brushy Bill was still rejected by serious Billy the Kid historians, including Maurice G. Fulton, who met Roberts outside the Lincoln Courthouse Museum during his 1948 tour of New Mexico. Even famous western novelist Louis L'Amour, who spent some time visiting Fort Sumner in the 1920s, got in on the debate, saying, "The idea that Brushy Bill Roberts was Billy the Kid is pure nonsense. The basic stories about Billy's last hours are true…I did hear the stories from their [old-timers, including Deluvina Maxwell] lips."

As with any mystery, more questions linger than answers have surfaced. C.L. Sonnichsen said it best in *Alias Billy the Kid*, which he concluded by writing, "And that brings up the final question—if Brushy Bill Roberts wasn't Billy the Kid, then who was he?"

BILLY THE KID

TREASURE HUNTER

Billy the Kid's ghost has walked in many forms.
—*J. Frank Dobie,* Apache Gold and Yaqui Silver

Though probably the least likely of Billy the Kid's claimants, the most interesting to discuss is that of Henry "Walkalong" Smith. Actually, to call him a claimant is a misnomer, as Smith never claimed to be the Kid himself; others did that for him after he was conveniently dead and could no longer speak.

Before others claimed that he was the Kid, Smith claimed to be an authority on Billy and was telling stories about the Kid's escape from Fort Sumner in July 1881. Smith claimed that Billy never ventured out to cut any beef on the night of July 14; he sent one of the Maxwell servants to do it instead, and they caught Garrett's bullet. Billy hid out in one of Maxwell's spare rooms as word spread that he had been killed.[30] Seizing the opportunity, the Kid and his friends decided to seal the deal of his death in an act of fakery. A hasty coffin was fashioned, the body of the servant boy was hidden and Billy then played dead in the coffin for the coroner's jury. This wild story told by Smith to John Graham in Reserve, New Mexico, could likely be what later led other old-timers to label Smith himself Billy the Kid.

Walkalong Smith, also known as "Fiddling" Henry Smith, was a wanderer traveling New Mexico who walked everywhere he went. Smith would often stay at secluded ranches, where he would earn his keep by teaching the

rancher's children reading, writing and sometimes music lessons[31] before he would mysteriously disappear. It was also said that Smith often played music at ranches in the company of a woman named Ira Shiely, though no information on this woman has been forthcoming. Smith never stayed in one place for long, and the only things he carried with him on his long journeys were a few books, some pencils and a weather-beaten writing tablet. He was also frequently seen browsing through the archives of the Governor's Palace in Santa Fe.

When Smith was found dead outside Lordsburg, New Mexico, in 1937, the truth of this enigmatic figure was finally "revealed" by the ranchers who had known him best. Henry Smith had really been Billy the Kid. According to the ranchers, during the aftermath of the Lincoln County War, Billy had captured the sympathy of Governor Lew Wallace. During a secret meeting, Pat Garrett and Governor Wallace had decided that the Kid was innocent for his crimes committed during the war and that he had only killed in vengeance and self-defense. Governor Wallace was still powerless to protect the Kid from the mighty Santa Fe Ring, so it was decided a shootout would be staged in Fort Sumner to fake the Kid's death, after which two bags of sand would be buried in an empty coffin and the Kid sent off to a prestigious university in secrecy.

Henry "Walkalong" Smith (right) posed with Kenneth Elijah Bain along Collingsworth Road in El Paso, Texas, circa 1937. *Palace of the Governors Photo Archives (NMHM/DCA), #105059.*

If the story is true, the Kid returned to New Mexico twenty years later at the turn of the century under the guise of

Walkalong Smith. But there's more. As if Smith's secret identity wasn't fantastic enough, he was also a treasure hunter searching for the Lost Adams Diggings. If Billy the Kid is New Mexico's most famous outlaw, then the Lost Adams Diggings is surely its most famous treasure.

The Lost Adams Diggings, which forms an epic tale unto itself, was a lost valley of gold found by a man known only as Adams in 1864. Adams and his party were led to the canyon, somewhere along the New Mexico–Arizona border, by a Mexican Indian named Gotch Ear. Upon arriving, Adams and his fellow prospectors found the richest gold placer they had ever seen, but only Adams would live to tell about it. All the men but Adams were killed by a group of Apache Indians led by Chief Nana, who had warned the men not to go beyond a certain point in the valley. Adams spent the rest of his life trying to find his way back to the enchanted canyon and died in the late 1880s.

Walkalong Smith wandered New Mexico collecting every bit of information he could find on the lost gold. More specifically though, Smith was making a thorough list of all the men who had been killed in search of it. If Smith ever did find the gold, people said he was doing it for the good of the state and would deliver the wealth from the gold to charity. Renowned folklorist J. Frank Dobie found some of the dead men on Smith's list interesting enough to include in his book *Apache Gold and Yaqui Silver*, nearly half of which is devoted to the Lost Adams Diggings.

While Smith may well have been a searcher for the Lost Adams Diggings, he most certainly was not a reformed Billy the Kid. Though it's true the two men did share a few similarities, such as a penchant for music and dance, as well as befriending and staying at the homes of ranchers, Smith was said to never touch a gun, not even to kill a rattlesnake. Of course, some say this is because Smith had let go of his wild gun-fighting days to lead a more serene, gentle life. Journalist Will Robinson, who would in the future cover the case of Brushy Bill Roberts, wrote of Walkalong Smith in the late 1930s, saying, "Frank Dobie tied [Billy the Kid] up with 'Silent Smith,' the mystery school teacher in the Deming terrain, this though [sic] Billy could read and write."

More likely than not, ranchers just decided to take advantage of the enigmatic figure of Smith, who said that he wished to die alone where no one would ever find his body,[32] and claimed he was the Kid once he died. Their story could have also been inspired by the fact that John Miller, the "other Billy the Kid," died in November of that same year, possibly before Smith's death, which J. Frank Dobie only says occurred "late in 1937."

One of the newer books to come out on Billy, *An Outlaw Called Kidd*, has what seems to be a story of Smith. In it, the unnamed man makes a surprise

visit to the Pete Grisak Ranch to see the owner's father. The man delighted the Grisaks by singing "Where Did You Get That Hat?" while playing guitar. After the man left, Grandpa Grisak told his son and grandson that the man was Billy the Kid. Of course, grandpa was probably pulling their leg, but it does sound characteristic of Walkalong Smith. However, this story takes place in 1942, well after he had died—that is, unless Dobie's dates were incorrect. New information has arisen on the matter, and it's uncertain yet whether it clarifies or just further confuses the matter.

Firstly, an article in the *El Paso Times* on July 26, 1964, mentions a retired immigration officer named Leslie Traylor who claimed that Billy the Kid was really Henry "Street" Smith, who was buried in the Arizona Pioneers Home under the name of John Miller. As it turns out, the Lincoln County Heritage Trust (LCHT) obtained an obituary of ninety-eight-year-old Henry "Street" Smith, who did in fact die in the Pioneers Home, albeit on October 17, 1955, not 1937. Smith was listed as being born in Kentucky and came to New Mexico in 1880. There he worked as an early day schoolteacher and also "helped survey the line between New Mexico and Arizona." This fits in with Lost Adams lore, which often stated it was along the border between the two states. For those now wondering if this was a different Henry Smith, he was not, for his obituary photo shows the same man in the two confirmed pictures of Walkalong Smith belonging to the LCHT. It would seem we have the usually reliable Dobie to blame for all this. He likely heard of Billy the Kid claimant John Miller's passing in 1937 and somehow mixed this up with a false story of Smith (who would have been in his seventies) dying along a roadside. Likewise, Leslie Traylor probably heard both Dobie's Smith story and Miller's, and when Smith being "Billy the Kid" in her mind passed away in 1955, she somehow became so confused as to say Smith was buried as John Miller. It is a tangled web indeed.

Whatever the case, any story that can combine Billy the Kid, the Lost Adams Diggings and an elaborate 1881 government conspiracy is certainly an interesting one.

DESPERADO DOPPELGANGERS

YET MORE HEIRS TO THE KID

The trouble here in Lincoln has been that the old-timers used to swing away in hammocks and spiel off exaggerations which could put any one of them in purgatory.
—Mr. Penfield, *store owner in Lincoln, quoted in* True West, *1960*

Though Brushy Bill Roberts, John Miller and Walkalong Smith make up the "big three" of Billy doppelgangers, they still don't end there. There is a veritable parade of other unnamed claimants and impostors. Though he doesn't elaborate, in a biography on Pat Garrett, author Leon Metz said that sightings of the Kid took place in "Mexico, in South America, in all parts of Western America, and even in Canada."[33]

In *Alias Billy the Kid*, a story is related by Helena Coe LeMay stating how her father, Frank Coe, who always investigated claims regarding Billy being alive, went to California to see a man who claimed to be the Kid. The man, a vagabond living in a shack, was just an impostor, to Frank's disappointment. The Coe brothers were two of the Kid's contemporaries who knew him best and actually believed him to still be living, or so some claimed.[34] Perhaps eventually the Coes did find Billy because there exists a 1929 statement allegedly made by George Coe to Bill Hagee, in which he tells the nine-year-old youngster, "You know, I could take you on a two day horse ride, 75 to 100 miles, depending on the terrain, and we could be talking to the Kid." Of course, he was likely just pulling his young listener's leg. However, an individual from the WPA interviews of the 1930s, said to be a cousin of John Poe's identified only as Mr. Poe, said Frank Coe claimed that he could

George Coe (far right) reclines in his rocker next to his granddaughter, Marie Coe Farrar, and guest Dan Storm. *HSSNM, #4714.*

The Rancho Linda Trading Post, owned and operated by the Coe family in Glencoe, New Mexico. *HSSNM, #4075.*

"saddle his horse at sunrise at his ranch on the Ruidoso near the resort there, and eat supper with the Kid at sundown."[35]

"Mr. Poe" also shared a wild nugget related to Pat Coghlan, "Cattle King of the Tularosa," who was often the buyer of Billy's rustled cattle. His right-hand man, Perry Carney, claims that Pat's two shots in the dark missed the Kid, who came by his place to grab a saddle right after the incident.

A wild tale printed in the June 29, 1926 *El Paso Times Herald* tells how "Billy the Kid is alive and resides within a radius of 200 miles of El Paso." The article relates how on the night of the fateful shooting in Fort Sumner, Garrett met up with Billy and gave him $1,000 to leave New Mexico and never return. Billy generously retorted that he only needed $25 and agreed to the deal, which also stipulated that he was not to touch another gun for twenty years. The body of another man was then planted in a grave that had been dug prior to the arrangement, and the article concludes that the "grave was marked by a rude cross, that was to prove to Billy's sister that he was still alive." Of course, the Kid had no sister, aside from the one who appears in a few other folktales.

Jim Blakely is another old-timer who alleged that Garrett didn't shoot the Kid but, rather, a Mexican sheepherder who was friends with the Kid. Blakely said, "His body was removed from the room and left on the ground outside the house. It lay there so long before burial that it started to decompose. The decomposition kept the coroner's jury from getting close enough to it to make positive identification."[36] Charles Roark, a contemporary of Billy's, told a story that the man killed in Maxwell's bedroom could have been the grandson of Maxwell's cook. The woman's grandson disappeared around the time of the Kid's killing, and after the burial, the cook frequently left flowers on "Billy the Kid's" grave.[37] It's most likely the "cook" referred to in this story is Deluvina Maxwell, who did indeed have a son, Felipe Maxwell, who died at a "young age," according to William Keleher in his book *The Fabulous Frontier*.

A similar story comes from John Graham, quoted by way of his nephew in a *Frontier Times* article. In it, Graham says he talked to the Kid in Fort Sumner during the daylight hours of July 14, 1881. Graham warned him that John Poe was in Fort Sumner that very minute looking for him. Billy only laughed and said that he was headed to Pete Maxwell's to get a better horse before taking off for Mexico. Later, when Graham heard the Kid had been shot, he went to Maxwell's to investigate and found that it was one of Maxwell's "muchachos" who had been shot and not the Kid, who was hiding in another room. Maxwell then had to petition Garrett for the body

until the sheriff finally relented and it was turned over to the Maxwell estate, the workers of which placed it on a workbench. Graham then helped to dig a grave for the unnamed Mexican man, though no historical accounts list Graham, or his alias John Collins, digging Billy's grave.

An article in the June 17, 1948 Carlsbad *Daily Argus* reports, "Carlsbad Man Says He Saw Billy the Kid Only Four Years Ago." The eyewitness was eighty-three-year-old J.W. Weldy—whom, it should be stated, claimed to have known Billy back in 1870s Roswell—who said he had run into the Kid at a dry goods store in Las Cruces four years prior. He recognized the old man as the Kid and asked him if he was, and the man said yes. The article states, "The man who was shot to death that night was a spy[38] for a cattle baron, Weldy says, but who killed him remains a question. He says it was neither Garrett nor Maxwell." The spy story is also told by one Manuel Taylor the same year in the June 27 El Paso *Times*. Taylor states, "The man killed at Maxwell's was a young cattle detective who had come in from the East and expected to make some easy money capturing cattle rustlers and 'got his' by mistake."

Curiously, there was also a less dramatic Kid sighting in Las Cruces in the 1920s. There, John Richards, who claimed to have known the Kid in the old days, says he saw the Kid walking down the street. When the two made eye contact, and the Kid knew he had been recognized, he swiftly disappeared.[39]

In an article appropriately entitled "Some Second-Hand Stuff About Billy the Kid," a vague mention is made of a man in El Paso "who has been getting a lot of free advertising" claiming that a surviving Billy is "playing fiddler for the festive Bailies...could start himself in the curio business if he'd only publish his name." It is not believed this article is referring to Brushy Bill Roberts, as he was well publicized, but it could be referring to the musically inclined "Fiddling" Henry Smith.

In 1933, famed lawyer/lawman Elfego Baca even got in on the search for the Kid and said that if he was still alive—and Baca doubted he was—the Kid would probably be disguised as a Mexican and speaking Spanish. On top of that, Baca, who claimed to have known the Kid in his youth, even said Billy used to use the last name of Baca from time to time. Baca had himself heard of an old man by the name of Bob R. Lewis who was a marshal in Magdalena, New Mexico, where he was approached by a man claiming to be Billy the Kid.[40] Aiding Elfego Baca in his quest to disprove the claims that Billy was alive at the time was Pawnee Bill, who, it should be noted, once employed Brushy Bill Roberts as one of the performers in his Wild West Show.

The most common myth about the Kid stated that he was still living in Mexico, and numerous sightings were reported of him. Some claimed the Kid would slip up from Mexico at night to visit his "friend" cattleman Oliver Lee, one of Pat Garrett's greatest nemeses in the late 1890s. An especially amusing story states that in 1940, Lee sent some of his men to Mexico to fetch the Kid so that he could watch the inaugural Billy the Kid pageant in Lincoln firsthand. This tale appeared in Zeke Castro's *An Outlaw Called Kidd*, which also presents another intriguing postmortem Mexican adventure of the Kid. "Once, probably about 1910, on their way back from El Paso, Texas the Kidd and his traveling companions, Damian Ortega and a lady name Rosa Linan were...heading south with a string of horses," writes Castro. The trio was taking the horses to sell to Fort Bliss, Texas, when Billy caught word of a plot to ambush them in the Oro Grande. The Kid, knowing they needed a distraction, recollected the story of Lady Godiva, the eleventh-century English woman who rode naked on horseback, and got Rosa to ride through the valley topless to distract the gang of robbers while the Kid and Ortega rode the horses safely behind a hill.

Castro's tales of surviving Kid clones conclude with another unnamed Kid claimant who was said to have been buried all the way over in England. This mystery man was said to have died sometime in the early 1950s near Dunken, New Mexico, after having been taken in at the Joseph Clements Ranch. After the death, mysterious men in black suits in a black car came by to pick up the body and transport it back to England for burial. Were they the Men in Black? No, but some speculated they could have been sent by the Tunstall family, who would bury Billy in England, where no scavenger hunters could desecrate his grave. A variation of this modern folktale was actually mentioned in a 2003 document from the Lincoln Sheriff's Department in regard to digging up the Kid in Fort Sumner entitled "An Investigation into the Events of April 28, 1881 through July 14, 1881—Seventy-seven Days of Doubt." In it is mentioned a headstone in England marked "William H. Bonney," said to hold the Kid, who had lived in England for the rest of his days with the Tunstalls.

If ever there was an old-timer who would have hoped to see the Kid alive and well, it was Deluvina Maxwell, who went into hysterics at the time of his death. Her obituary in 1927 stated, "Tales to the effect that Billy the Kid was not killed at that time [July 14, 1881] were refuted by Deluvina Maxwell whenever she heard them." And if anyone would know for sure, it was Deluvina, as she is usually reported to be the first one on the

scene to confirm the body in Maxwell's bedroom was that of her beloved Billy. However, in an interview conducted shortly before she died, Deluvina claimed it was Pete Maxwell who first reentered the room, and she did not see Billy's body until the next morning.

BILLY THE KID THE SECOND

Not all of the Kid's imitators actually claimed to be him; some were copycat desperados who just claimed to be his successors. According to Deluvina Maxwell, one such imitator in Las Vegas accidentally shot himself while trying to copy a signature trick of Billy's wherein he would whirl his gun around on his finger and then shoot. More notably, in 1883, a young man appeared who called himself "Billy the Kid the Second." The man's real name was Chester Cousins, and he arrived in New Mexico in 1881, the very year the Kid was shot and thusly on everyone's lips. Cousins was twenty years old at the time, and being nearly the same age as the deceased Kid, he grew to idolize him. As such, Chester purchased his own horse, saddle, gun, cartridge belt and holster. Soon he was strutting about San Marcial, where his father worked as a miner, stating, "Here goes the new Kid."

Chester even resembled Billy on a superficial Anglo level, being of five feet eleven inches in height and with smooth skin, brown hair and blue eyes. Unlike the real Billy, Chester wasn't forced into a life of crime. He could have become a miner with his father; rather, he simply wanted to be a criminal. And so Chester left San Marcial for the San Andres Mountains, where he joined a vicious band of cattle rustlers.

Kid the Second's first act of debauchery occurred on February 12, 1883. He and his bandit friends returned to San Marcial to cut up some capers and paint the town red. They began by trying to lasso a bull standing around outside a saloon and then, shortly after, began shooting at it. This attracted the attention of the town police, and a scuffle ensued. An officer named Navor Gomez began pounding on one of Cousins's cronies. When the man cried out, "Kid, Kid, he is killing me…Give it to him!" the moment of truth was upon the wannabe Billy. Cousins seized the moment and shot Gomez in the stomach several times. The new Kid had just killed his first man, and with the aid of his gang, he escaped San Marcial.

The incident made waves across the territory, and soon the *New Mexican* reported "Cowboy Capers—Six of Them Take in Old San Marcial and

Make It Warm for the Citizens of That Place." The article mentions Cousins by name and also refers to him as "Kid." It was Billy the Kid all over again, to Cousins's delight, as even Governor Lionel A. Sheldon was taking action to have the gang he belonged to brought in to justice. As Kid Cousins eluded capture, the papers followed his every move. Cousins was even brazen enough to take a train to Cerrillos and then stay in a hotel in town. According to lore, the hotel manager pointed out to Cousins that he was in the paper for murder, to which Cousins replied, "They are making a great deal of fuss about two greasers."

Initially, the town sheriff there didn't bother to arrest the Kid because his reward was for only $100, and Cousins escaped. So the governor upped the reward to $500, a price that had previously been on Billy's head. When Cousins arrived in Colorado, a sheriff's posse wasted no time in collecting the young outlaw the moment he stepped off the train. Cousins was then transported back to New Mexico under the escort of Sheriff Joe Smith. Unlike his idol, Cousins showed no humor or bravado on the train and instead became nervous and fidgety. In his article "The Hasty Career of the Copy Cat Kid," author John L. Sinclair writes, "They would hang Billy the Kid the Second in Socorro some future Friday dawn, just as they would have hanged Billy the Kid the First in Lincoln on Friday, May 13, 1881, if he hadn't of escaped."

Although Cousins was initially slated to stand trial and hang in Socorro, it was decided to take him to Albuquerque instead, as at the time Socorro was notorious for a vigilante gang. Even the head of the Santa Fe Ring himself, Thomas B. Catron, had been accosted by an angry lynch mob only the year before when he was in Socorro for a trial. Coincidentally, Socorro had recently lynched another outlaw going by the name of "Kid."[41]

The papers continued to report on Cousins, whom they said had been a professional gambler since the age of thirteen. Cousins had gotten his wish, it would seem: he was a mild media sensation (though he would get only fifteen minutes to the Kid's lifetime) and was placed in the Santa Fe Jail that March, same as the Kid had been two years prior. Cousins even met with the governor, who had come to give the $500 reward money to the Colorado sheriff. At this point, Cousins lost it and started bawling like a baby, confessing and regretting all that he had done. Feeling sorry for the lad, Sheriff Smith pressed a $5 bill into the boy's hands before he left. At Cousins's trial in Albuquerque, the bawling continued, and the young man confessed he had wanted to become an outlaw and implied that if set free he would reform—perhaps even become a Gospel preacher.

TALL TALES AND HALF TRUTHS OF BILLY THE KID

Cousins, in a Billy the Kid–like act, actually managed to free himself of his leg irons, but when he discovered the guard was watching him all the while, he began sobbing again and slipped the irons back on. Eventually, Cousins was found guilty of fifth-degree murder at his trial, and the women in attendance reportedly all broke down and wept. Cousins wasn't sentenced to the gallows though; the judge took pity enough on the boy and sentenced him to five years in prison. Billy the Kid the Second boarded a train bound for Kansas, where he would be incarcerated, and from there he disappeared from the historical record.

THE NEW KID IN (LINCOLN) TOWN

In the early 1990s, twenty-something William H. Cox II was taking a road trip through New Mexico. Stopping at the Roswell Museum and Art Center, the docent there, Ken Hobbs, told him that he looked just like Billy the Kid and he needed to go to Lincoln. Cox was already intrigued by the story of William Bonney thanks to the *Young Guns* films, and learning that he resembled the real deal only thrilled him all the more. Like Billy the Kid, William was also called Billy, and sadly, he also lost his mother at the tender age of thirteen.

When the folks in Lincoln saw Cox walk into the courthouse, they were immediately stunned by the resemblance. Cox was asked by Jack Rigney to stay in Lincoln and was told that there would be plenty of work for him there. At a party, a Hispanic girl placed a crucifix around Cox's neck and told him, "Welcome back, Billy. You've come back to us."

Cox's first official gig was more or less playing pranks on visitors to the courthouse museum in conjunction with the guides. After telling the story of Billy's escape, the guide would ask the visitors if they believed in ghosts. A short time later, Cox would walk by in Billy's signature stovepipe hat and dress to delight and/or frighten the audience. Most of the time, Cox made money by posing for photos with tourists and historians (such as Bob Boze Bell) alike. Soon he was even getting fan mail in Lincoln and took up residence there as a fixture of the town. Ironically, Cox often helped one of the descendants of Billy's victims, Sheriff Brady's granddaughter, carry her groceries inside the house for her.

Cox was no mere Billy impersonator; he indulged in quite a few Lincoln County adventures of his own, some infused with irony, such as the time

he got caught up in a cattle-rustling scheme. "I was accused of rustling and shooting cattle…and weeks later accused of breaking into one of the rooms at the Wortley Hotel previously occupied by Billy the Kid," Cox said in recent years.[42] While "hiding out" at Ken Hobbs's house in Roswell, Hobbs suggested the Lincolnites were just trying to stir up trouble. Cox informed some biker friends of the rumors being spread, and they politely offered to ride through Lincoln to send the townspeople a message, though it's unknown if they ever did so.

Things got hostile for Cox when he returned to Lincoln. Now he really was Billy the Kid, as some of the locals loved him and some hated him. One of the deputies—his own personal Bob Olinger, it would seem—was even threatening to haul him in for questioning as to the missing cattle. While Cox was eating breakfast at the Wortley Hotel, a rancher asked him if he had been "messing around" on his ranch. Billy's friends swiftly took to his defense and told the old rancher that harassment was illegal. "Not in Lincoln County," the old man quipped, and his cronies joined him in laughter. Before leaving, Billy said to the man, "I hear you like to drink a lot."

"I damn sure do, boy. What's it to you, boy?" he responded.

"I don't think you drink enough," Cox replied. It was the closest the new Billy would get to a saloon brawl.

For a time, Cox only visited Lincoln at night, but eventually, the rustling rumors began to die down. Since he was no longer posing for photos with the town's blessing, he did odd jobs building fences and even repairing the roof of the Ellis Store. While he was working on the repairs, a man in a blue truck stopped in front of the store and taunted Cox by twirling a gun in his hand and laughing at him. Cox fought back against the harassment by meeting with a syndicated reporter from Santa Fe who took down Cox's side of the story. At the end of the interview, the whole bar broke out laughing when Cox truthfully remarked that Lincoln was too hot for him right now so he would go to Fort Sumner to cool down.

When the story came out, Lincoln was portrayed unfavorably, rekindling an old rivalry between Fort Sumner and Lincoln. Now the political figures in Lincoln were madder than ever. Once, while at the Billy the Kid Museum in Fort Sumner, two of the rangers from Lincoln walked in, and Cox hit the floor to hide.

The last straw occurred when Cox snuck into the Wortley Hotel in Lincoln to meet a lady friend he had met in Fort Sumner. The next morning, the owner saw Billy walking out proudly smoking a cigar. Cox puffed some smoke in his direction and then promptly escaped via a mail truck to Roswell.

William H. Cox II strikes a familiar pose as Billy the Kid. *William H. Cox II.*

When Cox returned to Lincoln again, he brought a friend along who posed as a lawyer. When the deputy saw him, he began speaking into his radio, so the friend began writing on a notepad, which made the deputy cautious of his actions. All the townspeople who were friendly with Cox came into the street to see him causing a happy commotion. From afar, Billy shouted to the deputy, "Hey, when are you going to get with the new program?"

Just like the real Kid, Cox got shot at one late summer night in Fort Sumner while he was looking for a necklace he had lost. He never did find out who was shooting at him. And like the real Billy (and Brushy Bill for that matter), Cox even met the current governor, Bruce King, when he arrived via helicopter in Fort Sumner. The governor thanked Cox for all he had done for the state. Though Cox ultimately survived his New Mexico adventure, he decided to leave a cross with his name on it (complete with the dates he had been in New Mexico) at his friend's Fort Sumner ranch. He did so tearfully on December 31, 1991, and Cox's stint as Billy the Kid was over. Perhaps one day, someone will steal his cross as well, making the experience complete.

Cox published his adventures in an entertaining autobiography, *The Adventures and Times of William Cox II "Billy the Kid."* In 2014, Cox returned to New Mexico and was again the subject of much media coverage, with the story of his return even being picked up by *USA Today* thanks to reporter Kelly Brooks and the *Ruidoso News.*

CHAPTER 6
BILLY THE KID SLEPT HERE

FAVORITE HIDEOUTS OF THE KID

*If Billy the Kid hid out all the places people say that he did, he would never have
had time to rustle any cattle.*
—*Elvis E. Fleming*

Just as the northeastern seaboard is dotted with inns that claim "George
Washington slept here!" in New Mexico the same is true of Billy the
Kid. Locations all across the state boast that they were once "Billy the Kid's
hideout." As historian Elvis Fleming points out, the Kid supposedly hid out
in far more places than he possibly could have.

State officials began taking notice that Billy the Kid was good for
tourism revenue in the late 1920s, as evidenced by the December 19, 1929
article "Forest Service Marking Haunts of Billy the Kid," which begins,
"Responding to an interest by tourists in spots made historic by 'Billy the
Kid' and the Lincoln County war of fifty years ago, the United States Forest
Service has started marking historical spots and the forest roads leading to
them are being posted…The first place to be posted was the place where
John H. Tunstall, the first victim of the Lincoln County War was killed."

In a twist of irony that perhaps shouldn't be considered surprising,
many of the Kid's confirmed hideouts—such as Stinking Springs and Los
Portales—are not as profitable as tourist destinations compared to the ones
he used more fleetingly. Among the most popular hideouts are the ones
along the Billy the Kid Scenic Byway in the Hondo Valley. The first of these
is San Patricio, a small village where Billy often hid out with the numerous

Ralph Bonnell, a relative of George Coe's, inspects the Tunstall marker in 1957. *HSSNM #4044D.*

Spanish families there. The site is also very close to where John Tunstall was killed. Today, San Patricio is actually more famous for someone other than Billy the Kid: painter Peter Hurd. It is one of the few places in the Hondo Valley to escape the Kid's shadow. Hurd is best known for his paintings of the Hondo Valley and also being commissioned to do the presidential portrait for Lyndon B. Johnson. It would be remiss not to mention that Hurd portrayed Billy the Kid in the 1940 inaugural outdoor play *The Last Escape of Billy the Kid*.

Fox Cave, said to have been the hideout of both the Apache and Billy the Kid at one time or another, was the curio shop to stop at throughout the 1950s and 1960s. The location remained closed for many years until it recently reopened as the Fox Cave and Gem Mine, which also houses the Ruidoso River Museum. On display there is even a gun gifted to Pat Garrett when he served as customs collector in El Paso. Another hot spot is Ruidoso's birthplace, the Old Mill. Built in the late 1860s (and subsequently rebuilt after a bad flood), the mill was started by Will and Paul Dowlin but was eventually taken over by the Lesnett family in the late 1870s. It was the Lesnetts who would befriend Billy the Kid, said to stop by infrequently. To show thanks for being fed, he would often help with the dishes and even the Lesnetts' baby. Annie Lesnett claims to have hidden Billy in an empty flour barrel once, but typically, the Dowlins' mill was considered neutral territory during the Lincoln County War. One old article claims that Billy

the Kid and Pat Garrett gambled there.[43] Unlike many spots said to have housed the Kid, the Old Mill is legitimate in its claims of being "Billy the Kid's Hideout." The mill was also a hideout of Jesse Evans, who was almost apprehended there after escaping custody at Fort Stanton on April 12, 1879.

Another undisputed hideout is that of Blackhill, fifteen miles northwest of Las Cruces. Located at the western foothills of the Robledo Mountains on Black Hill, it is made of volcanic rock. There, Billy and his three pals—Tom O'Folliard, Charles Bowdre and Dave Rudabaugh—scratched their initials into the hard rock wall, specifically "Bonney," "O.F," "Bowdre" and "DR."

It's actually possible that Billy named New Mexico's very first state park, Bottomless Lakes, established in 1933 outside Roswell. James M. Miller relates in a chapter of *Reminiscences of Roswell Pioneers* how he spoke with the Kid about the lakes during a chance meeting at the Chisum commissary in South Springs near Roswell. According to Miller, the Kid was nursing a wound near his groin from a shot by J. Billy Mathews and hiding out in a cave in the bluffs east of the Pecos River shortly after the assassination of Sheriff Brady. In Miller's own words:

> *When I entered the store that day, the Kid was sitting on the counter, and as I got within earshot, I heard him say something about the Bottomless Lakes, as a natural curiosity not far from the cave in which Billy and his pals were*

TALL TALES OF A TEXAS HIDEOUT, BY ELVIS E. FLEMING

I grew up on a farm in Bailey County, Texas, and there was a natural lake about eight miles north of our farm called Monument Lake, which was about forty miles southeast of Portales, New Mexico. It used to be a stop on the wagon freight trail from Fort Griffin, Texas. My older brother, Floyd, told me what I considered to be local lore: that Billy the Kid used to hide out in some caves along the lake bluffs. When I first saw the caves in the 1940s, the distance between the floor and ceiling appeared to be only a few feet—not high enough for a man and surely not enough for a horse! My brother said they had caved in since Billy's day. Floyd was a "good ol' boy" who loved to spout "tall tales and half truths." I never heard the Billy story from anyone other than Floyd, so I don't know if this story is credible or not!

Fox Cave, along the Billy the Kid Scenic Byway, was reputed to have once been a hideout for the outlaw as well as the Apache. *HSSNM, #912.*

The Old Mill in Ruidoso as it appeared in the 1930s before restoration. *HSSNM, #1442A.*

Bottomless Lakes State Park located just outside Roswell, New Mexico. *HSSNM, #5566.*

The ruins of the "Skillet," an alleged hideout of Billy the Kid's, near Bottomless Lakes. *HSSNM, #3415.*

hiding. As I was a newcomer and did not know about the lakes, I asked why they were called "bottomless"? Billy answered pleasantly enough and explained that not long before, at a big roundup, he and some other "boys" had tied together all of their picket ropes, and had tried to find out the depth of two of them, without being able to reach the bottom.

In reality, the cowboys' lariats were merely swept away by underwater currents, giving them the illusion that the lakes were "bottomless." Nor are the bodies of water actually lakes but, rather, gigantic sinkholes. Billy also mentioned to the boy about seeing fish "as black as my hat." One of the more famous urban legends to emerge from Bottomless Lakes that persists to this day is that of giant catfish. This is on top of reports of other specters such as ghost horses, octopus men, giants and a Loch Ness–style monster said to haunt the lake.

There exist photos of a Billy the Kid hideout near the lakes nicknamed the "Skillet." But it's actually not possible that Billy was hiding out at the Skillet during the time that Miller spoke to him because shortly after the Brady killing, he was at Blazer's Mill near present-day Mescalero. However, the Kid could have hidden out near Roswell after the Blazer's Mill incident, and Miller could be confused about his dates. It is known for certain that the Kid and the Regulators were hanging around John Chisum's during and after the Fourth of July in 1878. According to Sallie Chisum's diary, he was also in Roswell in late August the same year. Whatever the case, the Kid likely hid out a time or two east of Roswell near present-day Bottomless Lakes. Miller is also the only one to attribute the naming of the lakes to the Kid, as most other Roswell historians simply list a group of nondescript cowhands naming the lakes; however, Billy could have been among their numbers.

Billy had one other notable hideout in present-day Chaves County that eventually became known as Billy the Kid Spring. It's actually the only hideout of the Kid's that was officially named after him and recognized by the state. It is located on the San Juan Mesa fourteen miles northwest of Kenna. The locale consists of a concave that houses a spring beneath an overhang. Local lore states the spring is cool year-round, as the sunlight never touches it. About one hundred yards from the spring are the ruins of a small dugout. It's entirely possible that the one place named for the Kid is a spot he never actually hid out in. This spot should not be confused with "Billy the Kid Cave" near Lincoln, which also housed a spring. It's possible Brushy Bill Roberts mentioned the cave on a drive through Lincoln with William Morrison in 1948. "A little farther down on the other side of the road, we ought to see a cave we used to use,"[44] he remarked.

One of the Kid's more famous hideouts—Los Portales, sixty miles east of Fort Sumner—was described in spectacular articles by the *Las Vegas Optic* as an impregnable castle. Supposedly, this hideout was elaborately decorated,

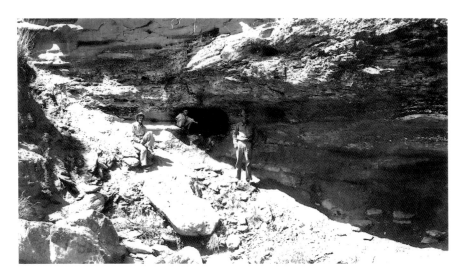

These unnamed explorers check out Billy the Kid Springs in Chaves County. *HSSNM, #1489D.*

and Billy romanced many fair maidens there. It was, in fact, just a small cave with a fifteen-foot-high ceiling. A 1931 edition of the *Portales Valley Herald* mentions how "several years ago several small boys tunneling back into the cave discovered a chair and a table which were supposed to have been used by [Billy the Kid] while in hiding."

The Jornada del Muerto (Journey of the Dead Man), near White Sands Missile Range, is one of the most notorious stretches of land in the Southwest. It was so named for an escaped German necromancer, Bernard Gruber, who died while crossing the desert in his escape in 1670. Not surprisingly, it, too, is the site of one of the Kid's alleged hideouts, a small cabin in a lush area called Ash Canyon. "Long-spurred golden columbine and scarlet pentstemon spangle the tall grass, and grow inside the ruins of a little stone house often occupied by Billy the Kid when he was on a quick move," wrote Margaret Page Hood in "Jornada Spells Adventure" for *New Mexico Magazine* in 1945. The Jornada del Muerto is more famous for being the site of an old Apache stronghold known as Victorio Peak, the legend of the treasure of which almost equals the Kid's notoriety.

The Kid was also said to have a cave hideout near White Oaks, described by J.Y. Thornton to Georgia B. Redfield in the 1930s: "Mr. Thornton, with a posse of nine men under leader John Hurley one day, entered a cave near White Oaks seeking the young killer and desperado. The Kid was concealed behind rocks at the fartherest [*sic*] end and was not discovered, but he could

"BILLY THE KID CAVERNS" IS CARRIZOZO'S HOLE-IN-WORLD

Dantesque Flow Of Lava Is Crossed To Reach Underground Caves, Miles In Extent, Soon To Be Explored By State Of New Mexico.

BY H. S. HUNTER
(Assistant to the Editor)

CARRIZOZO, N. M., Sept. 28.—
A system of caverns which lacks some of the spectacular features of the famous Carlsbad caverns, but is so huge that four hours' exploration in it scarcely touched it, so to speak, is soon to be explored thoroughly.

New Mexico state highway department has promised to make a survey of it as soon as possible, according to sheriff Sam Kelsey of Lincoln county, who knows more about these new caverns than anyone else here. It was he who, with two cowboys companions, spent four hours in them.

Lincoln county caverns lie across the malpais, or 60-mile long lava flow, and are about 10 miles east of Carrizozo. They are not in a mountain range but in foothill country.

They were discovered 15 years ago by J. M. Craven, pioneer ranchman and miner, who was in hot pursuit of a mountain lion. The lion ducked into a cave. Craven, who was not what his name indicates by any manner of means, went in after him. And there he was, in a second Carlsbad Caverns.

He did not get his lion. There were 10,000 places for it to hide and the chances were 9999 to 1 against finding it. At such odds, Mr. Craven was not a gambling man.

But he did find in the caverns the full military regalia of a redskin on the warpath; feathered headdress, bow and arrows. They were hanging on a rock projection. There was nothing to indicate why they were left there. Evidently, however, this was a retreat the Indians knew about.

Now the place is called Billy the Kid cavern. A legend has grown up that Billy, when too hard pressed, was wont to hide in this vast subterranean dive.

This may be true, or not. Inquiry so far has failed to bring to light anything to substantiate it: anyone who knows positively of Billy or his gang having gone there; any evidences in the caverns of white men's occupancy.

On the other hand, the chances are that if Billy knew of these caves he found them useful.

Unlike the Carlsbad Caverns, the entrance is easy. There is no long stairway to descend. With a little work to smooth the way, one might drive a car into them.

We have the word of sheriff Kelsey that he found, in his four-hour tour, only easy walking.

The formation is limestone, as in the Carlsbad Caverns, but except for size, the opening caves are unimpressive. They are dry. There are not the stalactites and stalagmites in all their grotesqueries that make the Carlsbad Caverns so weirdly fascinating.

In the depths, however, these formations caused by the dripping of lime-impregnated water begin to manifest themselves. It is sheriff Kelsey's belief, from what he saw, that water is in the lower caverns and that there one will find the same fantastic orgies of nature as north and now visitors to the Carlsbad Caverns.

A guess that the extent of the Billy the Kid cave is considerable is based on the assertion that wells drilled as far as five miles from the mouth struck caverns below them.

Some of these lower caverns, bitten into by ranchers' drills, were filled with torrents of water so swift as to sweep away the drilling tools.

Sheriff Kelsey and his companions, whose names he does not recall, came out of the caves without difficulty through sheer luck.
"I don't know how we managed to get out as we did, now we kept from getting lost," said the sheriff. "We laid down no line of string with which to trace our way out. We simply went in, wandered around for hours, and came out.
"Some of those great rooms have as many as six entrances, all looking about alike. We were lucky enough to hit the right ones.

"Less than 250 yards from the entrance is a room approximately 200 feet in diameter. It is round. Its ceiling is a perfect dome, decorated with small limestone pendants of the same kind as found in the Carlsbad Caverns.

"The ceiling rises from a height of only a few feet at the wall to a maximum of probably 75 feet above the floor at the center of the room.

"Far back in the interior we came upon a chasm which our ears told us was of awe-inspiring depth.
"What little I know about it came to me in the following manner:
"I sat down to rest in a little room that bordered on the chasm, which was a great, black hole.
"I could hear my companions above me. They had followed another corridor which took them

An old newspaper article detailing the discovery of "Billy the Kid Caverns." *HSSNM.*

have shot each one as they entered the cave if he had desired. He afterwards said they all had once been his friends and he couldn't shoot them down unless they had him cornered and forced him to do so."

Then in 1928 came the discovery of Billy the Kid Caverns in Carrizozo near the famous Valley of Fires Lava Flow. Part of the headline proclaimed, "Dantesque Flow of Lava Is Crossed to Reach Underground Caves, Miles in Extent, Soon to Be Explored by State of New Mexico." The article states:

Now the place is called Billy the Kid caverns. A legend has grown up that Billy, when too hard pressed, was wont to hide in this vast subterranean dive.

This may be true, or not. Inquiry so far has failed to bring to light anything to substantiate it: anyone who knows positively of Billy or his gang having gone there; any evidences in the caverns of white men's occupancy.

On the other hand, the chances are that if Billy knew of these caves he found them useful.

This sums up the tales of Billy's hideouts pretty well. If it was in New Mexico and Billy the Kid could have passed through there, a journalist or an entrepreneurial peddler would label the locale one of "Billy the Kid's hideouts."

DID BILLY THE KID KNOW JESSE JAMES?

Old desperados never die; they do not even fade away. They arise from their ashes,
full of strength and stories.
—*C.L. Sonnichsen,* Alias Billy the Kid

O f Billy the Kid and Jesse James, it's difficult to say which is the more famous of the two outlaws. Both were contemporaries, and legend says they met during their real lives—and for certain in their fake lives thereafter through their decrepit doppelgangers, J. Frank Dalton and Brushy Bill Roberts.

The historical Jesse James had more than a few similarities to Billy the Kid, starting with his slight stature of five feet nine inches and weight of 135 pounds. Like the Kid, despite being an outlaw, many claimed he was really a Robin Hood–like figure who stole from the rich and gave to the poor. He was said to love a good practical joke. One of his more comical exploits included interrupting a political speech after just committing a bank robbery to inform the crowd of the act and suggest that they go untie the poor souls inside because, as he put it, "We've got to be going." James also once left a note for the police at the scene of a train robbery, asking that it please be printed in the paper "as is" rather than being grossly exaggerated by the police or a reporter.

The James brothers rode with Quantrill's raiders during the Civil War, and it's possible they knew Captain Joseph C. Lea, the future "Father of Roswell" and a political enemy of the Kid's. While the Kid was really just a cattle rustler, James was in the big leagues, carrying out numerous bank, stagecoach and train robberies. Some of the thefts netted the outlaws upward of $60,000.

James was shot and killed not long after his contemporary Billy the Kid on April 3, 1882. Coincidentally, the July 30, 1881 obituary for Billy the Kid in the *Kansas City Journal* quipped, "Here in Missouri is needed just some such man as Pat Garrett. He who will follow the James boys and their companions in crime to their den and shoot them down without mercy." And indeed, James was shot in his den in the back by "the coward" Robert Ford, a recent addition to James's gang. To keep vandals from digging up Jesse's grave (perhaps the family was aware of accounts of Billy's corpse in Fort Sumner), the outlaw was buried right outside his mother's front door seven feet under. Twenty years later, his body was moved to the Mount Olivet Cemetery. When his grave was exhumed, his skull tumbled from his casket, proving, if nothing else, that no vandals had stolen any bones. Like Billy's death, conspiracies surfaced questioning whether the outlaw was really dead or just faking death. A local paper reported right away that there were rumors James was still alive and it was an impostor who had been shot in a coverup involving the entire James family. And like Billy, James had more than one impostor. James's nephew joked that since his uncle's death, he had had eleven uncle Jesses.

In 1946 emerged the most well known of his claimants, J. Frank Dalton. He even had an accomplice of sorts, a man named Orvus Lee Hawk who claimed to be the grandson of Jesse James and called himself Jesse Lee James III. Dalton borrowed a number of tales from an earlier Jesse James impersonator from the 1920s who called himself John James, who had conveniently just died. John James claimed to have shot a man named Charlie Bigelow who looked just like him to fake his death, while Dalton claimed that Ford killed Bigelow,

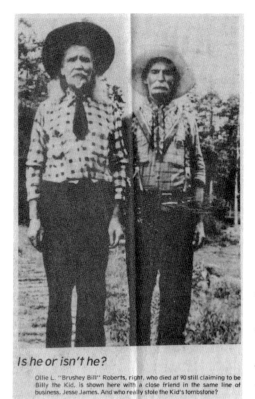

Is he or isn't he?

Ollie L. "Brushey Bill" Roberts, right, who died at 90 still claiming to be Billy the Kid, is shown here with a close friend in the same line of business, Jesse James. And who really stole the Kid's tombstone?

Brushy Bill (right) poses with J. Frank Dalton ("Jesse James") in an old newspaper clipping published after both men's deaths. *HSSNM.*

and he then went on the run to South America. Dalton received a whirlwind of publicity from that day forward until his death. It should be noted that Jesse James's grandchildren considered Dalton to be a fake. Though Billy the Kid has only been threatened with a DNA test, one was actually performed on the remains of Jesse James to compare to his descendants. It came back 99 percent conclusive that James was killed in 1882.

Birds of a Feather...

In a twist that strains credibility, Dalton was friends with O.L. "Brushy Bill" Roberts. A photograph exists of Roberts and Dalton together at the latter's 102nd birthday party in 1948. A Cole Younger (who had, in fact, died in 1916) was also present for the party. The photo's caption alleges that Roberts's and Dalton's fathers rode together in the Civil War, though Roberts claimed he first met Jesse James at Belle Starr's ranch in Texas. Another source indicates that at one time the two men were even neighbors.[45]

Whatever the case, Roberts was part of Dalton's circle before he began claiming to be Billy the Kid on a wide scale. Brushy Bill appeared in a parade (in the second car) in J. Frank Dalton's honor on July 7, 1948, in Guthrie, Oklahoma. Also present were Jim Thorpe,[46] famous Native American athlete; Captain Roy Aldrich of the Texas Rangers; a few RKO movie stars; and Al Jennings, reformed outlaw. It's worth wondering if the two chatted about "old times," since Brushy Bill claimed to have pursued Jennings in a train robbery during his time in the U.S. marshals, and Jennings was also rumored to have worked for John Chisum. Whatever the case, Jennings later admitted that he was paid $100 to "admit" that Dalton was Jesse James.[47]

In another amusing coincidence, it's interesting to note that since the real Jesse James died one year after the real Billy the Kid, the impostor Dalton followed suit, dying one year after Brushy Bill Roberts on August 15, 1951. He is buried in Granbury, Texas.[48]

Did the Real Kid Meet the Real Jesse James?

The real Billy the Kid was rumored to have met Jesse James back in 1879 while gambling in Las Vegas, New Mexico (not to be confused with its Nevada

counterpart, despite the circumstances). This story comes from an old frontier doctor named Henry Hoyt, who was working at the time as a bartender at the Exchange Hotel. In his memoirs, *A Frontier Doctor*, published in 1929, Hoyt relates how he encountered his old friend Billy the Kid at the Hot Springs Resort,[49] a precursor to the famous Montezuma Hotel, north of the town site. Unlike many who claimed to be "old friends with Billy the Kid," Hoyt actually was.[50] Hoyt and the Kid began talking about old times in Tascosa, Texas, when Billy eventually introduced Hoyt to his dinner guest, a "Mr. Howard from Tennessee." Back in the Kid's room, he told Hoyt (under a pledge of utmost secrecy, of course) that "Mr. Howard was none other than the bandit and train robber, Jesse James." James was impressed with the Kid and had tried to get him to join up with him, but train robbing was not on his agenda. However, Homer Cory in *Jesse James Was My Neighbor* says that it was the Kid's offer to team up and it was James who turned him down. In any case, the Kid met James, he said, through mutual friends, Mr. and Mrs. W. Scott Moore,[51] who owned and operated the Hot Springs Resort. Hoyt writes:

> *Jesse James had been in seclusion for some time; Mr. and Mrs. Moore were former friends whom he could trust, so he came out to size up the situation in a new territory. Billy also knew the Moores, and as he had not seen a passenger train since he was a youngster, he had slipped into Las Vegas, discarded his cowboy togs for an entire new city outfit of clothing, and was having the time of his life for a few days at the Hot Springs… The Moores, finding themselves hosts of two of the most conspicuous outlaws the West had ever known, brought them together, and they apparently became friends.*

Hoyt, "Howard" and the Kid met again that evening and had a nice visit, with Hoyt remarking, "Mr. Howard little dreaming I knew his identity." While one could surmise that the Kid, who was known to string a good yarn, just told Mr. Hoyt that Jesse James was his dinner guest to pull his leg, the famed Missouri outlaw actually was in Las Vegas at the time, and James did indeed use Howard as an alias, renting a house in St. Joseph, Missouri, as Mr. Thomas Howard. Also, the *Las Vegas Optic* reported that "Jesse James was a guest of the Las Vegas Hot Springs from July 26th to July 29th. Of course it was not generally known." Furthermore, Miguel Antonio Otero relates that he, too, was introduced to Jesse James by the Moores and said of the outlaw that he was polite and well dressed. According to Otero, James was possibly looking to relocate to New Mexico, which is also what Hoyt claims, and left Las Vegas by train with little fanfare. Oddly, Otero never mentions seeing Billy the Kid, whom he knew. Herein lies

UNCLE KIT CARSON

It would seem that there was an entire network of Old West impostors in Dalton's camp that also included a Roswell man born in the late 1850s called Uncle Kit Carson, who, although he wasn't obnoxious enough to claim to be Carson himself, did claim to be his nephew. In Carson's collection were letters from Jesse James III and also "O.L. Roberts," who signs off by calling Carson "dad." A letter to Uncle Kit dated April 1, 1949, from Dora, New Mexico, reads: "Dear uncle kit Carson…dad we heard from Billie the Kid he is doing fine We are Looking for him to come home he will stay with us 2 weeks thin he Will go over sea for 3 years dad I will do my best to get Billie the Kid to come By and see you…Love and Best wishes to you from your son OL Roberts."

Uncle Kit Carson, one of the more eccentric residents of Roswell, who claimed to know Dalton and Roberts. *HSSNM, #2218.*

In later years, the letter was found by historian Elvis Fleming to match Uncle Kit's own handwriting, meaning he wrote the letter to himself to drum up some controversy. Uncle Kit, it was eventually discovered, was really a circus performer named Ora A. Woodman.

the story's problem: while Jesse James was very likely there (Hoyt even recalls James's nub finger), historically speaking, the dates don't add up for the Kid being in Las Vegas. Lincoln County War historian Maurice G. Fulton ascertains that the Kid remained in deep hiding from July to September of that year and never left DeBaca County. On the other end of the spectrum, just as positively as Fulton argued against the meeting of the two desperados, James's own half brother John T. Samuels says James did indeed meet the Kid in Las Vegas and propositioned him to join his gang.

It would be remiss not to mention that during the time that James and the Kid visited Las Vegas, Doc Holiday was operating his famous East Las Vegas "gin-

BILLY AND JESSE MEET DRACULA AND FRANKENSTEIN!

In the mid-1960s, there appeared a strange horror film double bill featuring the two outlaws. Billy was the hero of *Billy the Kid vs. Dracula*, while Jesse starred in *Jesse James Meets Frankenstein's Daughter*. Shot in only eight days, *Billy the Kid vs. Dracula* featured John Carradine (who considered the film the worst he had ever made) as the Count, whom he had played before in Universal's *House of Frankenstein* and *House of Dracula*. *Billy the Kid vs. Dracula* and *Jesse James Meets Frankenstein's Daughter* were produced back to back and written by the same production team. They were released together in March 1966 by Embassy Pictures, which touted them as "The NeWest in Terror-tainment!" So far as anyone knows, neither film was inspired by historical events.

mill" on Centre Street. It's entirely possible that the Kid gambled at Holiday's establishment. Doc Holiday, best remembered for his participation in the 1881 gun battle at the O.K. Corral at Tombstone, Arizona, departed from Las Vegas with Wyatt and James Earp for Arizona in October 1879. Whether Billy knew Holiday or not, Doc is portrayed as a friend of the Kid's in Howard Hughes's *The Outlaw* (1943).

A story appearing in *Bill Jones of Paradise Valley, Oklahoma* by John J. Collison relates a tale that the Kid and James were enemies. It goes that when Bill Jones was working on a Colorado ranch owned by Missouri native, and friend of the James brothers, Dave Pool, a good-looking young man came to work on the ranch. This same man later disappeared with several horses and cattle. The young rustler, it was said, was Billy the Kid. Soon the real owners of the ranch showed up, who were actually the James brothers, Frank and Jesse. The brothers and their posse—which also included Cole Younger, Bill Gregg and Ike and George Berry—took off after the Kid and his ten-man gang. A gunfight ensued, and only the Kid and one other managed to escape under the cover of darkness. So there you have it—in this tale, one outlaw steals from another!

It's surprising that there are not more legendary tales of the two outlaws grouped together. So whether Billy the Kid and Jesse James ever really knew each other is still up for debate, but it's apparent that their later-day doppelgangers knew each other for sure.

BRUSHY BILLY AND NEW MEXICO GOVERNORS OF PAST, PRESENT AND FUTURE

I feel a certain responsibility [to pardon Billy the Kid] *if Lew Wallace made such a promise.*
—*Governor Bill Richardson, 2003*

Much like Charles Dickens's classic *Christmas Carol* character Ebenezer Scrooge and the three ghosts he encounters, Billy the Kid—or, more specifically, Brushy Bill Roberts—has a unique relationship with New Mexico governors of past, present and future. If Thomas Mabry could have been considered the present governor in Brushy's saga, then General Lew Wallace represents the past and Bill Richardson the future.

BILLY'S BROMANCE WITH THE WRITER OF *BEN-HUR*

In the late 1870s, after the violence in Lincoln had reached a fever pitch, it finally drew the interest not of the current governor, Santa Fe Ring sympathizer Samuel Axtell, but President Rutherford B. Hayes himself. Hayes had Ring boss Thomas Catron resign as a U.S. attorney, and Axtell was terminated as governor. His replacement was Civil War general Lew

Wallace, who also had a literary career as an author. Wallace was working on a new novel to be called *Ben-Hur: A Tale of the Christ* when he took up residence at the Governor's Palace in Santa Fe.

Wallace's first act to settle down Lincoln was to grant amnesty to all the Lincoln County War's participants, except those already indicted for crimes, which included the Kid. A smooth negotiator, Billy wrote a letter to Wallace stating that he would testify against the murderers of Houston Chapman, a one-armed lawyer recently gunned down by James Dolan and Jesse Evans, among other things. Wallace agreed to meet with Billy in person, alone, in the home of Squire Wilson in Lincoln on the night of March 17, 1879, St. Patrick's Day. When the Kid entered that night, Wallace was found inside alone with Squire Wilson, just as promised. Folklore states that Wallace told Billy, "You don't look at all as I had pictured you in my mind." Billy replied, "No? I left my horns and forked tail back at camp."[52] The two got along splendidly and negotiated a deal in which Billy would be arrested in a fake capture, so as to testify about certain events from the war, and then a pardon would be granted to him.[53] In the June 8, 1902 New York *World*, Lew Wallace wrote a firsthand account of this meeting:

> *Then I unfolded my plan. "Billy" was to be seized while he was asleep. To all appearances, his capture was to be genuine. To this he agreed, picking the men who were to effect his capture. He was afraid of hostile bullets and would run no risk. Another stipulation was to the effect that during his confinement, he should be kept in irons. "Billy the Kid" was afraid also of the loss of his reputation as a desperate man. The plan agreed upon in the cabin on the lonely mesa at midnight was carried out to the letter.*

Observing Billy in captivity in Lincoln, Wallace seemed to be fairly endeared to Billy, calling him in a letter a "precious specimen named 'The Kid'" and "an object of tender regard" among the villagers. Billy even gave Wallace a shooting lesson during this time, despite the fears of the guards. In a July 29, 1881 article in the *Grant County Herald*, a sort of posthumous biography on the Kid, Governor Wallace is quoted as calling the Kid "that brave boy" and "that wild young knight errant." The article also reminisced that Wallace "lost sight of his crimes in the romance of his devilishness."

The warm and fuzzy bromance between the two quickly dissipated during the court of inquiry to indict Colonel Nathan Dudley, who had set fire to the McSween house during a siege in Lincoln; he was eventually acquitted. Feeling the changing of the tide, and perhaps even becoming a little bored, Billy casually slipped off his shackles and told his guards, "Boys, I'm tired

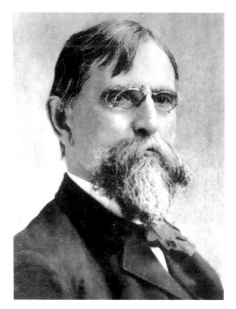

Right: Governor Lew Wallace, "pal of Billy the Kid" and later "enemy of Billy the Kid." *HSSNM, Larkham Album.*

Below: The Juan Patron Store, where Billy the Kid was serenaded during his voluntary arrest. *HSSNM, #5160.*

JUAN PATRONS STORE LINCOLN, N.M. WHERE BILLY THE KID CARVED HIS INITIALS ON DOOR AT RIGHT

of this. Tell the General I'm tired." Billy didn't even run, according to legend; he merely walked to his horse and then trotted off on his way to Fort Sumner. In the end, the Santa Fe Ring won another battle, this one in the courtrooms, and despite giving his testimony as he had promised Wallace, Billy was denied his pardon by a New Mexico judge.

TALL TALES AND HALF TRUTHS OF BILLY THE KID

After this, according to legend and hearsay, things became strained between Billy and Wallace. "I mean to ride in to the Plaza at Santa Fe, hitch my horse in front of the Palace and put a bullet through Lew Wallace," the Kid supposedly said. At the time, Governor Wallace was up late at night writing *Ben-Hur* near a well-lit window. According to legend, Mrs. Wallace would close the blinds every night at dusk out of fear for her husband's life. After being sentenced to hang on April 13, 1881, Billy's intentions were made public in the Las Cruces *Semi-Weekly*, which stated, "He [Billy] is a notoriously dangerous character…and has made brags that he only wants to get free in order to kill three more men—one of them being Governor Wallace."

Author Kenneth Osthimer attributes this all to Santa Fe Ring gossip:

> *The claim put forward by the wife of Governor Lew Wallace, in a letter to her son—that Billy the Kid was "chief" among the "desperadoes and outlaws" alleged to be responsible for what she termed "the reign of terror in Lincoln County"—in the light of documented evidence, turns out to be nothing more than some pro-Ring gossip she "heard" then making the rounds in New Mexico…She informed her son that one of her friends (obviously the same friend who was passing these Ring canards around) had "warned" her to "close the shutters at evening, so the bright light of the student's lamp might not make such a shining mark of the governor working till late on* Ben Hur.*"*[54]

However, a month prior to Billy's alleged threats, Wallace was already far away back east promoting the finished *Ben-Hur*, while Billy was busy writing him letters and trying to tunnel out of the Santa Fe prison in March 1881. Not long after that, Wallace tendered his resignation as governor to President Garfield, and thus the Kid and New Mexico were no longer his problem.

In Wallace's defense, it should be noted that Billy actually got a second shot at a pardon. This time, the pardon involved the Kid helping to expose a ring of counterfeiters in White Oaks. Billy then unknowingly shot himself in the foot, so to speak, when he robbed a U.S. Mail coach that carried documents crucial to exposing the counterfeiters.

As for Wallace, *Ben-Hur* was a runaway hit for the ages that eventually spawned epic feature film adaptations and even tie-in merchandise. Billy the Kid wasn't the only western connection to *Ben-Hur*. When it was adapted into a stage play in 1899, it starred William S. Hart, a future western movie star and a past pallbearer at Wyatt Earp's funeral.

BRUSHY BILL, GOVERNOR MABRY, PAT GARRETT AND UFOS

Governor Lew Wallace's pardon for Billy the Kid would eventually come back to haunt the New Mexico government (and, even later, New Mexico taxpayers in the 2000s) in the form of Brushy Bill Roberts, who claimed to be a surviving Billy the Kid in the late 1940s. Aided by paralegal William V. Morrison and lawyers from the law firm of Andress, Lipscomb and Peticolas, Roberts wanted to get the pardon that he felt was owed to him. The petition for a pardon from current governor Thomas Mabry took a good two years to create (mostly in the form of obtaining signed affidavits of those still living who recognized Roberts as Billy the Kid) and was filed on November 15, 1950. While Governor Mabry didn't agree to a pardon for Roberts, he did agree to a meeting to consider it. Morrison made arrangements for the trio to meet, along with a few selected historians, in the chambers of the governor's mansion in Santa Fe on November 29.

While stopping in Albuquerque for breakfast with Roberts that morning, Morrison was startled to see a newspaper proclaiming that the governor's meeting with "Billy the Kid" would be open to the public. An angered Morrison called Mabry, who apologized and explained that word had leaked to the press and said that he and Roberts could come earlier for a private meeting at 9:30 a.m., entering through the back door.

Mabry's promised earlier private meeting devoid of the press was rendered void when Morrison and Roberts arrived at the mansion,

OTHER GOVERNORS KNOWN BY THE KID

It would be remiss to not also mention that Billy met two future governors of New Mexico during this period of his life. He met Miguel Antonio Otero (1897–1906), who was about the same age as the Kid, while he was incarcerated. Otero was one of the first men to write a favorable defense of the Kid and is also significant for giving an early Hispanic perspective on Billy in his book *The Real Billy the Kid.* During the Lincoln County election for sheriff in 1880, Billy also met future governor George Curry, who succeeded Otero from 1907 to 1910. When Curry was eating breakfast with Billy the Kid in 1880, Curry let slip that he believed Pat Garrett would win the election for sheriff. Billy told him that if he believed that he would make a "damn poor politician."

which was already crawling with reporters. It was an all-out media circus; it was not even really a meeting between Mabry and Roberts so much as a press conference. To make matters worse, also present among the reporters were Sheriff Brady's grandson Arcadio Brady and two of Pat Garrett's sons, Oscar and Jarvis.[55] Brady would have made Roberts especially nervous, as this was the grandson of the man Roberts was charged with murdering and the reason he was originally sentenced to hang. Once the questions began firing from reporters, Roberts fell apart and couldn't even remember Pat Garrett's name. Supposedly this media circus is what caused Roberts to crack under pressure, becoming "confused" and unable to recall key dates and names.

Two men with family pasts in Lincoln, Louis Leon Branch and Louis Zamora, sat in on the event, and Branch later wrote in his book *Billy the Kid y los Billitos*:

> *The old man didn't know a thing about Billy the Kid or even the name William Bonney. He stammered and stuttered through all his answers until it was obvious to all that he didn't know what he was talking about. There were many reporters and two tall men, one of whom wore black western pants, a black shirt and vest, boots, and a big hat. I immediately recognized them as the Garrett boys. The resemblance of one of them to Pat Garrett was to me so strong that for a minute I felt like we were re-living something straight out of the past.*

Amidst the assault of questions, Roberts had to be excused so he could go lie down in a private room within the statehouse. Some even claim the stress brought on a small stroke or heart attack. Once Roberts recovered enough to get up, Morrison took the old man back home while Mabry announced to the press that he would not grant Roberts a pardon because, in his opinion, he wasn't Billy the Kid. The official press representative, Will Robinson, also concluded Brushy Bill was a fake. Mabry, it's worth noting, was Robinson's daughter Jane's father-in-law. Poor Roberts—Billy the Kid or not—died a month later.

As for Mabry, he was also governor during another media sensation three years earlier when a UFO allegedly crashed outside Roswell near Corona in Lincoln County in July 1947. Mabry's lieutenant governor, Joe Montoya, was even in Roswell during the incident and supposedly saw the alien bodies. Mabry himself was involved to a lesser extent but would have been aware of the incident. He also visited the Roswell Air Field a few months later. Allegedly, a few bits of saucer debris still remained there at this time. If this is true, then Governor Mabry was directly involved with New Mexico's two greatest

unsolved mysteries: the Death of Billy the Kid and the Roswell Incident, which now equals the Kid in terms of New Mexico legend. One of the leading Roswell investigators, Tom Carey, co-author of *Witness to Roswell*, said this of Mabry:

> *Regarding Tom Mabry, at the time of the Roswell Incident, the plan was to get everybody who would receive questions about it from the press "out of town," such as* [Colonel William] *Blanchard,* [Walter] *Haut and* [Jesse] *Marcel. This also included the governor of New Mexico. He was due in Roswell on July 9th to sign The Air Force Proclamation, but took an impromptu "vacation to the mountains" with his wife instead. He was "on ice" for about two weeks and didn't resurface again until a governors' conference in Utah two weeks later.*[56]

One has to wonder if Brushy Bill Roberts saw the newspaper releases on Roswell in 1947, as, being "Billy the Kid," a mention of his old stomping grounds should have caught his eye. Actually, Pat Garrett has a tenuous connection to the Roswell Incident himself. Garrett, who was shot to death outside Las Cruces on February 29, 1908, was thought to be the victim of an elaborate conspiracy. The supposed conspirators consisted of W.W. Cox, Albert B. Fall (of the Tea Pot Dome scandal fame), Old West assassin Jim "Killer" Miller and the alleged patsy Jesse Wayne Brazel. Brazel was none other than the uncle (or second cousin, depending on the source) of Mack Brazel, who found the flying saucer wreckage on a Corona ranch in Lincoln County in 1947. For its sizeable acreage, New Mexico truly is a small state.

BILLY THE KID MEETS BILL RICHARDSON

Like the real Billy, even death couldn't stop Brushy Bill Roberts from attempting to get a posthumous pardon. In 2003, three Lincoln County sheriffs decided to officially reopen the case of the Kid's death in Fort Sumner by exhuming his remains there and those of his mother, Katherine Antrim, in Silver City; Brushy Bill Roberts in Hico, Texas; and even old John Miller in Prescott, Arizona. Once DNA could be harvested, they would all three be tested against that of Mrs. Antrim, the Kid's proven historical mother. Whoever's DNA matched hers would come out the real Billy. Suspected motivations for the investigation included promoting tourism, personal financial gain or perhaps some other conspiracy too strange to even speculate upon. Whatever the case, newly

elected governor Bill Richardson became involved. Richardson was something of a master at publicity, making it into the Guinness Book of World Record for the most handshakes given out in an eight-hour period.

Richardson planned to have hearings in Silver City, Las Cruces, Lincoln and Fort Sumner. In late 2003, he hired his lawyer, Bill Robins, who did the work pro bono and even helped with some of the costs. Robins was also one of Richardson's major political donors when he ran for office and did so again when he ran for president in 2008.

Speaking posthumously through Robins at a court hearing in Silver City, Billy formally requested as an heir of Katherine Antrim to have her exhumed.

In the end, the crucial sites of Fort Sumner, Silver City and even Hico declined the exhumations. Only John Miller and an adjoining burial plot next to his were exhumed, and bizarrely, Miller's "friend," or the random man in the next plot, was tested against some old DNA scraped off a bench that Billy supposedly bled out on. Even Dr. Henry Lee, of the O.J. Simpson murder trial fame, was involved in the case. If this doesn't make sense to the reader, don't worry—it doesn't make sense to much of anyone.

Defending themselves from the radical digs also cost the towns of Fort Sumner and Silver City a fair amount of money, which is ironic considering that some believe the whole charade was put on in an effort to boost tourism. Gale Cooper, who fought against the exhumations, postulates that Bill Richardson was merely using Billy the Kid to gain national recognition and publicity before his 2008 presidential run. Cooper also points out that attorney Bill Robins was an avid believer in the Brushy Bill Roberts case and hoped to get him his pardon via Richardson. Had all gone as planned, Roberts would have been exhumed and tested against Katherine Antrim, proven to be the real Kid and gotten his pardon.

Cooper stipulates in her book *Mega Hoax*, "As Richardson's big political donor, Robins was backing him for president in 2008. If 'Brushy' was to be Robin's pay-to-play prize, contemplate this: Mad 'Brushy' may have risen to a kingmaker—or presidentmaker!"

When the plot to exhume the bodies failed, Richardson brought up the issue of pardoning Billy one last time before he left office, polling people across the state to ask whether he should do so. Finally, on December 31, 2010, on his last day as governor, Bill Richardson announced on ABC's *Good Morning America*, "I've decided not to pardon Billy the Kid because of a lack of conclusiveness and the historical ambiguity as to why Governor Wallace reneged on his pardon."

It was also too late by this point to run for president or reelection.

MEN THE KID NEVER KILLED

The Kid was a bad feller; I ain't disputing that. But he made considerable history in New Mexico as long as his trigger finger held out.
—Charlie Foor, in Saga of Billy the Kid

The most popular myth regarding Billy the Kid is the "fact" that he killed twenty-one men, one for each year of his life, which most likely originated in the *Santa Fe Democrat*.[57] Emmerson Hough's *Story of the Cowboy* likewise states the Kid was twenty-three when he died and killed twenty-three men, while those who allege the Kid was actually twenty-four years old also credit him with the killing of twenty-four men. When a reporter asked Pat Garrett if the Kid killed twenty-one men, he answered that he killed eleven. The author surmised, "I thought one for every two years for his life was nearly enough."[58]

Ironically, some of the Kid's most famous victims were men whom the Kid didn't actually kill, if they ever existed at all. Most of these tall tales originated in Pat Garrett's ironically titled *Authentic Life of Billy the Kid*, which was padded out by Ash Upson's imagination. The kill order in *Authentic Life* is firstly the man who insulted Billy's mother, followed by three Chiricahua Apache, a blacksmith, a monte dealer in Sonora and then another in Chihuahua, fourteen Mescalero Apache who attacked a wagon train and yet another unknown number of Indians near the Guadalupe Mountains. This is all prior to the Lincoln County War, mind you.

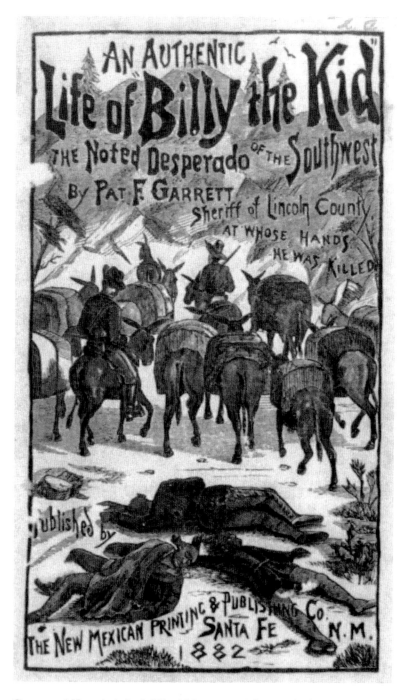

Garrett and Upson's *Authentic Life*, which perpetuated many classic myths about the Kid. *Author's collection.*

It was Upson's first invented victim of the Kid's who would go on to live in infamy, however, as many an old-timer mistook the tale for the truth and began passing it off as such when reporters came calling in the 1930s.

BILLY'S FIRST KILL

Historically speaking, the Kid's first killing occurred in Arizona, when he shot blacksmith Windy Cahill in self-defense on August 18, 1877.[59] But for authors like Ash Upson, unaware of this, or perhaps aware and just looking to elaborate, Billy's first killing was a mythical opportunity, and many writers seized it with zest.

The first to do so was actually not Upson but John W. Morrison in *The Life of Billy the Kid, a Juvenile Outlaw*. The story had Billy and his brother, Joe, walking down the New York streets with some friends. One of them, Thomas Moore, said something objectionable to the Kid, so he rushed into a local store and came out brandishing a large knife, with which he stabbed Moore in the neck. The tale is set in 1876, long after Billy left New York, if he ever even lived there.

Upson chose to elaborate on the oft-repeated story that Billy's first kill was a man who insulted his mother when he was twelve. However, Upson did not create this story entirely, and it was apparently circulating for some years prior, as the July 28, 1881 *Grant County Herald* states in Billy's obituary, "The story that he killed his 'first man' for insulting his mother is a fabrication." Probably aware of the fact, it didn't stop Upson from writing in his own book, "As Billy's mother was passing a knot of idlers on the street, a filthy loafer in the crowd made an insulting remark about her." In Upson's version, Billy didn't shoot the man on the spot, as some stories say, but rather punched the man in the face. He later killed him in a bar fight with a knife when the opportunity presented itself. Though in Upson's story the man was a bum (Upson identified him as a "blackguard"), in hearsay versions he transforms into a blacksmith, perhaps tying into the Kid's real first victim, Windy Cahill.

Oddly enough, this story about Billy killing a blacksmith who insulted his mother in Silver City is backed up by the Coe brothers, both of whom claim Billy told them the story himself. George Coe told Miguel Antonio Otero that the Kid told him in confidence that the first man he ever killed was a blacksmith in Silver City. Billy's stepfather forced him to work for the domineering man, who often beat Billy and never paid him. The last

straw came when the man insulted Billy's mother, so he procured a gun and shot him. "This was Billy's own account of the beginning of his career," Coe said.[60] However, Coe was known to borrow stories from others when he couldn't remember them on his own.

In a series of newspaper articles by the *Las Vegas Gazette* predating his death, Billy's first victim is a Chinaman who gets his throat cut from ear to ear. This is a mighty big elaboration of Billy aiding Sombrero Jack in stealing some laundry from an Asian man in Silver City. Billy has also been falsely accused of killing a Chinaman in a poker game; this, too, no doubt traces back to the laundry theft in Silver City and seems to combine it with the Kid's "killing" of Don Martinez from *Authentic Life*.

In *History of the Mesilla Valley* by John Griggs,[61] the Kid is attributed with twenty-seven killings, his first victim being a miner who ran off with Billy's fifteen-year-old sister.[62] The problem wasn't the age of his sister but rather the fact that the miner refused to marry her because he was already married himself. And so Billy bought a six-shooter and shot him.

According to J. Frank Dobie's book *A Vaquero of the Brush Country*, or rather a man quoted in it, the twelve-year-old Kid waited tables at a restaurant operated by his mother at Fort Union. The cowboys took to calling him Billy the Kid, while the Negro soldiers started calling him Billy Goat. As he would walk by, they would make the bleating noises of a goat to mock him. When one lone buffalo soldier did this to Billy one day, he threw a rock at the man. The soldier went for his gun and so did Billy, and thus he had killed yet another "first man."

In the 1926 book *Frontier Dust*, the author, John Lord, relates a tale that one of John Chisum's men, a cook, was Billy's first victim. The Kid and the cook got into an argument, after which the cook threw his frying pan full of hot grease at the Kid, who immediately took out his gun and shot the man.

THE KILLING OF THE CHISUM MEN

Second to the man who insulted his mother among the Kid's notorious non-killings are the three Chisum cowboys. Billy had some bad blood with John Chisum, as he claimed he was owed wages by Chisum that were never paid to him during his time as a Regulator. Initially, the two men's relationship was said to be good, and Henry Hoyt in a letter stated that Billy "looked upon Chisum as the greatest man in the world," but he may

have been confusing Chisum with John Tunstall, whom Billy did indeed admire. As for Deluvina Maxwell's two cents on the feud, she claimed, "Billy the Kid told me before he died that he was not so mean before he worked for Chisum."

Historically, Billy stole Chisum's cattle to get even, but in legend, he vowed to hunt down all of Chisum's men. This apocrypha is thanks to the *Las*

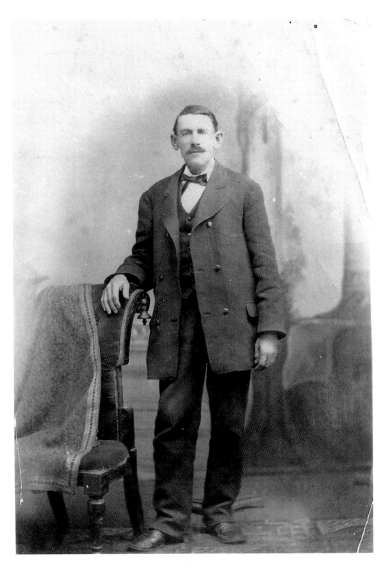

John Chisum, "The Cattle King of the Pecos," a powerful man whom Billy vowed to kill. *HSSNM, #604D.*

Vegas Optic running a story on June 10, 1881, that Billy approached a cow camp near Roswell and asked one of the hands, "Are you working for old John Chisum?" When he answered yes, the Kid quipped, "Well, here is your pay," and shot him dead. Then Billy turned his gun on the other three men and killed two. The third he let live and told him to deliver this message to Chisum: "Tell him during the Lincoln County War he promised to pay me $5 a day for fighting for him. I never got a cent. Now I intend to kill his men wherever I meet them, giving him credit for $5 every time I drop one." The article dramatically concludes that "at the rate he [the Kid] is now going, he will soon depopulate Lincoln County."

As some sources quote, Billy believed Chisum owed him $5,000.[63] That would mean he would have to kill one thousand men to get even! Of course, Chisum didn't even have one thousand men under his employ.

Many of the old-timers considered this story to be fact, and one, Travis Windham, commented, "As an outgrowth of this, Billy the Kid did the one mean thing—the one thing and only thing that I really held against him. He killed two of Chisholm's [*sic*] riders who hadn't done a thing to him and in a cold blooded manner. He did it as a warning to his employer."

Then there is a tale of Billy killing a few men at Fort Concho related by Bill Cole, who claimed to know a man, Dave Martin, who had camped for a night with the Kid when he was headed back from Fort Concho on the

Many of the Chisum riders at South Springs, circa 1881, whom newspapers sensationally claimed the Kid planned to kill. *HSSNM, #588.*

trail. Martin was heading toward the fort, so Billy told him, "Well, when you get there the next day you'll see my mark. I'm Billy the Kid." When Martin arrived in Fort Concho the next day, he found two men freshly buried, both of whom had worked for Chisum.[64]

There is an alleged prelude to this Chisum feud story set in the same saloon where Billy shot Joe Grant, where he encounters John Chisum. Interestingly, in the Anglo version of this story, Billy threatens Chisum for the wages owed to him, and "Uncle John" gently and diplomatically talks his way out of it unharmed. In the Hispanic version, Billy sticks his gun barrel in Chisum's mouth and humiliates him in various ways, such as making him dance like a rooster, before sending him out the door with a kick to the rump. Folklore also states that it was no coincidence that John Chisum "left the country" shortly after the Kid's escape from Lincoln, though the dates for this don't actually add up.

BILLY THE BIGOT?

Billy the Kid was much loved among the Spanish peoples of New Mexico, and Paco Anaya once said Billy preferred to be with Hispanics rather than Anglos. Don Martin Chaves of Santa Fe also once said, "[Billy] never killed a native [Hispanic] citizen of New Mexico in all his career." This is regarded as historically accurate, but some Anglo old-timers tried to paint a different picture.

Travis Windham from Pecos, Texas, relates some of these tall tales in an old weathered newspaper clipping from the late 1920s. In it, he states that there is a legend among the people in New Mexico that Billy never once killed a Hispanic. "But on the Pecos," Windham stated, "there is just as positive a tradition to the effect that Billy once killed an outfit of Mexicans, three or four, in a little house somewhere between Carlsbad and Artesia." Supposedly the men were squatters whom John Chisum hired Billy to get rid of.[65] Windham also relates how when working in a Texas outfit, he had received a letter from the manager in Dallas stating that if Billy the Kid ever showed up to give him whatever he wanted so as to avoid even greater trouble from the boy if they denied him. So one day when Billy showed up asking for horses for him and his men, Billy got what he wanted.

In a scathing 1930s critique of the Kid by Will Robinson in "Billy the Kid Rated Only as a Western Gun-Man," the journalist states, "He [Billy the

Kid] played no favorites as to races. He shot and killed Indians, Mexicans and Anglos, who might have something he wanted, or who threatened to be enemies or the allies of enemies." Robinson also relates a story that Billy killed one of his Mexican *compadres*, Celeste Garcia, simply because he wanted his horse. "Many of the Mexicans were off Billy, as soon as the facts in this case became known," Robinson concluded, though it should be noted that his article was full of inaccuracies. Frontier marshal Fred E. Sutton claims that the Kid once killed two Mexicans "just to see them kick" and also makes an allusion to the murder of the Chisum men. However, Sutton was a notable teller of tall tales whose stories were written down by A.B. MacDonald in *Hands Up!* In it, he also exaggerates that more than two hundred men were killed in the Lincoln County War. Likewise, Emmerson Hough ups the number of Mexican men the Kid killed "to see them kick" to seven in *The Story of the Cowboy*. An unnamed Santa Rosa sheriff was once quoted as saying, "The Mexicans sort of favored the Kid, even though they knew damn well he knocked off quite a few of 'em down below the border."[66]

While Billy did indeed share a camaraderie with the Hispanic peoples, despite the above stories—all of which are likely apocryphal—he showed Native Americans no such love. *Authentic Life* tales aside, there are many rumors of instances in which Billy the Kid took part in the killing of Apaches. The Kid told Paco Anaya himself that he killed five Apache eight miles west of Roswell who refused to sell Billy a horse. J. Frank Dobie also mentions hearing that the Kid "helped to ambush and murder three Apache Indians for their store of pelts and blankets," though this is likely lifted from *Authentic Life*.

J.E. Sligh (a partner of Ira Leonard, who represented the Kid at Mesilla) tells a story in a 1908 issue of *Overland Monthly* of a heroic act on the part of the Kid. A rancher near Fort Bayard left his family to go off into the mountains. Upon leaving, four Apache crept up to the house and attempted to rape his wife, but Billy the Kid appeared miraculously out of nowhere to save the woman. In the process, he killed three of the Apache and ran off the fourth.

Pedro M. Rodriguez, of Carrizozo, told a whopper of an Indian battle concerning the Kid during a FWP interview in 1938 in which he recounted:

> In the posse was Billy the Kid, Andres Herrera, Manuel Silva, George Washington, and grandfather. They started out early one morning for Turkey Canyon. When they got to Turkey Spring about half way up the Canyon, they met Chief Kamisa and about twentyfive [sic] Indians. Kamisa was Chief of the Mescalero Apache Indians. While the posse was

*talking to Chief Kamisa the Indians formed a circle around the men and
told Kamisa to tell them they were going to kill every one of them. Billy
the Kid told the men in Spanish, to get off their horses and tighten up their
front cinches and follow him. Billy mounted his horse with a six gun in each
hand, and started hollering and shooting as he rode toward the Indians.
The rest of the men followed, shooting as they went. They broke through
the line of Indians and not a one of the men were hurt. They gathered a few
head of cattle and took them home and put them in a corral.*

KILLER FOR HIRE

Among the many other tales of hearsay spread by the old-timers during the
FWP interviews of the 1930s is one painting the Kid as a sort of ranch hand
killer and oppressor. It was told by George Bede of Fort Worth, Texas, who
recounted tales of the Kid told by his father. Bede said:

Another thing I often heard about was that he [Billy] *was a dependable
fellow to use in settling long standing accounts between the ranch owners
and cowhands. In those days a greener would be stood off for his pay by
some of the ranchmen. Cash was hard to get at times, and when it was
scarce the settlement with the greener would be delayed at times on general
principles...In many cases, so it was told (and no one denied it as not
being the fact), when a greener went to squawking too hard Billy the Kid
would be called upon to settle the account. The settlement would be made
by sending the greener out with the Kid to pull a critter out of a bog. The
Kid would send the greener into the bog to tie the rope on the animal. While
the party was making the tie the Kid would load him so full of lead that the
fellow would also become bogged down. Father told me that, while he never
seen Billy do any of the settling, he did personally see several fellows that
got to squawking and suddenly disappeared. The last seen of the fellows
they were riding off with the Kid.*

THE MANY LAST ESCAPES OF BILLY THE KID

Most accounts of the Lincoln County War are far from true.
—Martin Chavez, actual participant in Lincoln County War, as quoted in
The Real Billy the Kid

Billy the Kid was sentenced to hang on Friday, May 13, 1881. Prophetically, a newspaperman, Simeon Newman of the *Semi-Weekly*, wrote, "We expect every day to hear of Bonney's escape." And escape he did two weeks later from the Lincoln County Courthouse in what became the defining moment in Billy the Kid's desperado career. Not surprisingly, numerous versions of the event exist depending on who's telling the tale. In his biography of Pat Garrett, Richard O'Connor wrote, "Whether told by one of Billy's able biographers or an obscure reporter for one of the country newspapers in the area, the escape story is a maze of contradictions."[67] Actually, the *Las Vegas Optic* first reported the details of the escape on May 2, and by its May 3 follow-up, "The Double Tragedy," it already had begun revising accounts of the escape. The general version is that while Pat Garrett[68] was away on business and Bob Olinger had taken five other prisoners to the Wortley Hotel for lunch/dinner, Billy was left alone with James Bell and at some point managed to free himself from his handcuffs and overpower and reluctantly shoot Bell with a gun he somehow obtained. As Bob Olinger heard the shot, he left the Wortley to go investigate. Billy was waiting for Olinger on the second story of the courthouse with a shotgun. Once Olinger was within range, Billy quipped, "Hello, Bob" and then blew him away. A German cook named Godfrey Gaus then helped Billy get one

of his leg irons off and fetched the bandit king a horse belonging to Billy Burt. After mulling around Lincoln for about an hour, Billy rode off into the sunset (some versions place the story occurring around noon and others at dinnertime around 5:00 p.m., which is more likely).[69]

Paco Anaya's *I Buried Billy* represents a good example on variations in the escape common among old-timers. The Kid's story told to the Anaya family of how he escaped the courthouse is markedly different. Billy claimed an unnamed lady friend smuggled him in a knife via a tortilla. Maybe Billy was pulling his listeners' collective legs, but he claims he hid the knife by stuffing it up "you know where." When he asked to go to the privy every day, he took it out, cleaned it and then used it to whittle a key from some wood, with which he eventually opened up his handcuffs. He used his shackle to bash Deputy Bell over the head and then shot him in the back with his own pistol, which he retrieved from Bell. The story also deviates here in that Olinger wasn't taking the other prisoners to lunch but had gone out to get cigars for him, Bell and Billy. After Billy shot Olinger, Bell regained consciousness (this is the only version of the story in which this happens), and Billy had to shoot the poor deputy again, this time with a Winchester rifle. In this rendition, Billy also had to threaten the friendly Gaus to bring him a horse, which here belonged to the long since deceased Emile Fritz.

The above paragraph is only one variation of many, and what follows below are the various differences in other accounts, starting with Billy's first deadly move on Bell. Though typically it is thought Billy didn't go to dinner because he was considered too dangerous to be taken from the courthouse, at least one

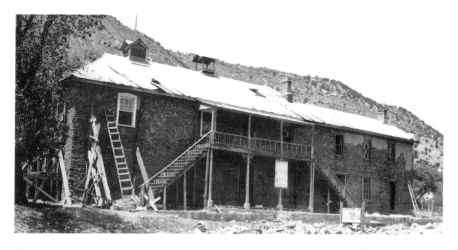

The Lincoln Courthouse in a state of disrepair before a restoration via the WPA program in the mid-1930s. *HSSNM, #2140.*

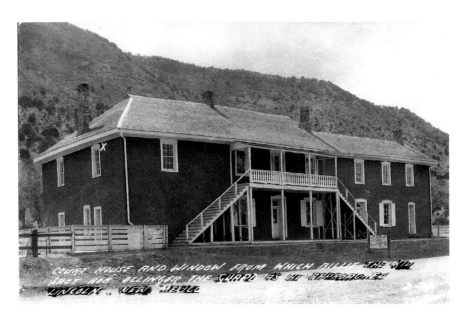

The Lincoln County Courthouse after a restoration undertaken by the WPA program, which revitalized many old structures in New Mexico. *HSSNM, Larkham Album.*

version exists in which Billy chose not to go because he said he was sick. Some even say Billy starved himself during his incarceration to make himself thinner and thus better able to escape. In other versions of the story, Billy managed his escape because he and Bell were enjoying a card game together, one of many that would end up being fatal for Bell.[70] In his generosity, Bell had allowed Billy to take off his heavy handcuffs to play the game. The Kid took advantage of this and then bashed Bell over the head with one. In another version in which they play cards, Bell was leaning over to pick up a card that Billy had "accidentally" knocked onto the floor, at which point Billy lifted his revolver from his gun belt. It's worth noting that George Coe and Walter Noble Burns both use this version of the story.[71] In another, Billy pretended to fall asleep, and Bell let down his guard to read a newspaper.

As to versions in which Billy managed his escape thanks to a trip to the outhouse with Bell, which turns up in all the more credible stories, most involve a gun being hidden there. Some say a small boy placed it in the privy, and a good deal of others claim it was placed there by Jose M. Aguayo.[72] A few oral histories say Billy was tipped off as to the gun's whereabouts by Sam Corbett. In other versions, the gun or knife didn't come from the latrine; Billy just managed to get ahead of Bell on the way back inside the courthouse and broke a gun out of the armory, which he then used to shoot Bell. In most versions, Billy is

BILLY THE KID AND THE NUMBER THIRTEEN

Author of many Billy the Kid pulp articles in the 1960s, Carl W. Breihan was fond of pointing out the Kid's strange association with the ominous number thirteen. Historically speaking, the Kid was found guilty on April 13, 1881, and sentenced to hang on Friday, May 13, 1881. To top it all off, there were thirteen letters making up the name of Judge Warren Bristol, who sentenced Billy to hang in Lincoln County, which itself has thirteen letters. Of course, then there are the thirteen knots in a hangman's noose and the thirteen steps leading up to the hanging gallows. Many of the names in the Lincoln County War, including William Bonney, consist of thirteen letters. Included in this bunch are Charlie Bowdre, Dave Rudabaugh and Richard Brewer, all three of whom died violent deaths. The Kid missed being killed on the thirteenth by only one day and was shot on July 14, 1881, instead. Macabre coincidence or merely a pulp writer at his best?

sad to have killed Bell, but in one version, Billy threw his handcuffs at Bell after he was dead. In another version, Billy didn't ask to go to the privy but to look around downstairs where the old Murphy store used to be. Another tells of an invisible line down the center of the room that the Kid was not to cross. On the day of the escape, he did so deliberately. As Bell scolded him, Billy sheepishly backed away, and when Bell got close enough, Billy attacked him.

In most versions, Bell managed to stumble outside and die in the arms of Gaus. As soon as Olinger came running out, Gaus is typically quoted as saying, "Bob, the Kid has just killed Bell!"

"Yes, and he's killed me too!" Olinger replied in more flamboyant versions of the story before he got blown away.[73] More likely, Billy simply said, "Hello, Bob" and then shot. The Kid is also quoted as saying, "Hello, Bob, old compadre"; "Hello, Bob. Please turn around so I can look you in the face"; "Look up, old boy, and see what you get"; and "Oh, Olinger, remember what I told you?"[74] Sometimes after Bob's death Billy shoots the corpse with the second barrel and then breaks Olinger's beloved shotgun and hurls it at him, shouting, "Take this also!" In one version, Billy managed to do all this with his handcuffs still on and took them off after both killings by making his hands slippery with soap. Sometimes Billy walks past Bell and says that he's sorry, while Olinger he kicks

with his boot and says, "Take that, too, damn you. You won't follow me anymore with that gun," or, "You are not going to round me up again." Supposedly, the lumber Garrett went to White Oaks to purchase that day for the gallows was then used to make coffins for Bell and Olinger instead.

Whatever the case, the animosity between the Kid and Olinger had been long-standing. Pap Jones, husband of the famous "Ma'am Jones of the Pecos," tells in a story that he once met Billy in a Lincoln saloon and told his friend how Bob Olinger had murdered his son John. Pap planned to kill Olinger, but Billy told him that he was too old and that Billy would take care of it. The Kid then used his escape as the perfect opportunity to exact justice on Olinger. Garrett actually specifically chose Olinger as his guard due to the hatred that existed between him and the Kid. Some even say Olinger created a miniature noose that he would swing in front of Billy's face to torment him. Gaus is also said to have disliked Olinger,[75] who complained about his cooking. On the subject of Gaus, he is said to have known about the escape ahead of time in some fanciful circles.

And then there is the horse Billy rode out on, almost always belonging to Billy Burt, which the Kid promised to return. The horse usually comes back into Lincoln the next day (though Martin Chavez says it took only two hours and came complete with a thank-you note), dragging a rope. One version says a young boy brought the horse back at the Kid's request. Some versions also have the Kid riding sidesaddle because of the leg shackles, though in almost all versions Billy managed to free at least one of his legs. Sometimes the horse comes back with blood on the saddle, which Billy told Pete Maxwell belonged to a jackrabbit he killed. In another, the horse comes back pulling a yucca stalk it had been tethered to, implying the Kid probably wasn't done with the horse before it began its journey back to Lincoln.

As Billy rides off, most versions end with Lincoln residents wishing him well. Some say the Kid shook their hands, some say the Kid sang a song as he left and some say he whistled. There are a few reports to the contrary, one of which is from Garrett, who implies the townspeople were terrified. Daniel Carabajal, then a boy, stated in a 1939 FWP interview that "we hid behind a picket fence and watched Billy ride out of town. We were too scared to go and see the two men that he had killed, we were afraid that he would come back and shoot us." Other stories say Billy stayed in the top floor of the courthouse for an hour carrying on like a maniac, yelling, whistling, laughing, singing and dancing all the while (had there been a pump organ inside to play, Billy probably would've been said to do that maniacally as well). In another, Billy threatened the locals at gunpoint not to come near him. And

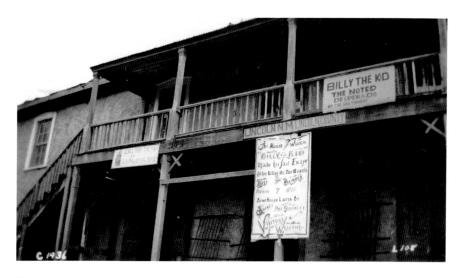

Signage proudly proclaiming its history on the part of the Kid. *HSSNM, Larkham Album.*

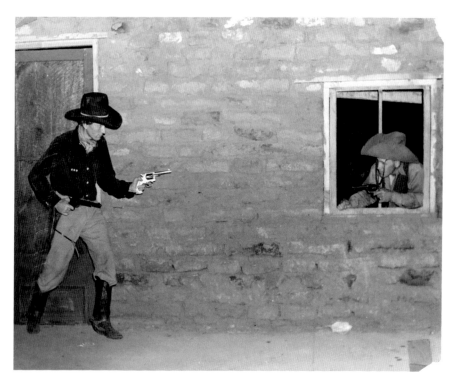

Peter Hurd as the Kid in the inaugural Billy the Kid Pageant, then called *Billy the Kid Lives Again*, circa 1940. *Palace of the Governors Photo Archives (NMHM/DCA), #105502.*

in yet another, he addressed the townsfolk from the balcony of the courthouse. According to John Meadows, this address went something like this: "I am going to give the good people of Lincoln a chance to think a little. I'm not going to hang on the day they have been expecting I would." Then the Kid reached into his boot, pulled out a folded-up piece of paper and dropped it, letting it fall to the ground below. "I don't think I'll need that now," he quipped.[76] A Dr. Tomlinson investigated its contents later to find that it was crystalized strychnine, a type of poison.[77] Martin Chavez heard, secondhand as well, that Billy said to the townsfolk, "I have no friends today. If anyone is tired of living, just let him follow me and show his head." Billy then rode off singing:

I go to the plains with much sadness,
And never again shall return.
And with patience I'll wait for my passing,
And no one will weep when I'm gone.

Of all the town residents, only one man—the saloon owner J.A. La Rue, who had helped get Pat Garrett elected—grabbed a gun with intentions of stopping the Kid, but his wife, in turn, stopped him.

Just about everyone in Lincoln County claimed Billy came to see them after his escape for a meal, good old John Meadows among them. And perhaps he did. In any case, several different people are credited with getting Billy's shackles off for him, though all agree he eventually ended up at his friend Yginio Salazar's ranch. As for alterations and tall tales, the family of Ladislado Salas says Billy came riding up to their house sidesaddle and that he was a short man with a black mustache. An old item in the *Portales Daily News* carries a story by Yginio Anaya, who claims Billy stopped in at his house after his escape. There, where he was said to be despondent about his outlaw status, he begged Yginio's father to turn him in and collect the reward money.

Another popular legend goes that Billy was so heavily armed after the escape that he needed to get rid of some of his weapons. According to legend, he placed two of his guns and two cartridge belts into the fork of an oak tree, and now, somewhere in the Capitan Mountains, there lies an old oak tree with the Kid's guns grown into its heart. Brushy Bill Roberts, it's worth noting, said of his escape route through the mountains, "My guns began to get heavy and I hung one of them in the fork of a tree." There even exists someone who found the legendary tree in the form of Yginio Salazar's grandson James "Ruby" Salazar. As a boy in the late 1930s, Salazar was heading to school crossing the Bonito River going toward Lincoln when

he spotted a nogal (or walnut) tree that had a lone rusty revolver that had become trapped in the fork. Too young to pry it out, Salazar never got to retrieve the gun, as the tree eventually got old and rotten. Finally, a flash flood washed the tree away and carried it down the river.[78]

The tale of Billy's escape would also not be complete without telling what happened to Don, the horse that Billy stole from the Three Block Ranch after he sent Billy Burt's horse back to Lincoln. Billy rode Don a full one hundred miles from Capitan Mountain to Fort Sumner. When Billy soon after gave the horse to Pete Maxwell, he told him that the horse was "wind-broken" from the hard ride, and he was never to be used in trail drives or hard labor again. Maxwell kept his promise, and when he sold his ranch to Lonnie Horn of the New England Cattle Company, he insisted he could not sell Old Don, per Billy's instructions. Horn, not a romantic by any means, didn't care to purchase the horse under those circumstances, so next Maxwell approached the ranch foreman, Jack Potter, who, being sympathetic, agreed. Potter later said, "I do believe that Don was one of the best horses I ever rode but that was only around camp when I was moving slow. He was so badly wind-broken that he would choke if he traveled any faster than a walk. I kept him for six years until he died at our horse camp on the Mora after drinking too much alkali water."[79] Before his 1890 death, Don was supposedly so loved by the ranch hands that they even spoiled him with biscuits dipped in molasses.[80]

THE LOST TREASURE OF J.A. LA RUE?

The Lincoln saloonkeeper with intentions of shooting Billy, J.A. La Rue, also has a tenuous connection to the Victorio Peak legend. This connection is by way of the Lost Padre Mine of Father La Rue, said to be a part of the Peak's treasure. It is rumored that J.A. La Rue once grubstaked some prospectors who found the then unnamed "padre silver mine" in the Organ Mountains. The story was then "garbled" to become that of Padre La Rue's lost treasure. John Meadows also curiously mentions the owner of a mine in White Oaks named La Rue in *Pat Garrett and Billy the Kid as I Knew Them*. In the *New Mexico Magazine* article "The Lost Padre Treasure of Victorio Peak," in which this story appears, author Fern Lyon—oblivious to J.A. La Rue's actual existence—humorously writes, "And anyway, whoever heard of a saloon keeper named La Rue?"

THE KID'S GHOST AND OTHER LEGENDS

Sometimes the stories the old-timers tell have more real truth in them than the books ever tell.
—C.L. Sonnichsen

Being dead and gone, and also of much controversy, Billy the Kid was as good a subject as anything for cowpunchers to talk about around campfires, chuck wagons, poker tables and bar stools, whiskey firmly in hand. As such, there may well be more legends on the factual William H. Bonney than there are on the purely fictitious Pecos Bill. But as the C.L. Sonnichsen quote above states, perhaps more wisely than we know, sometimes the stories recounted by the old-timers had more truth to them than one might think. That being said, most of the eclectic grouping of stories below (aside from a select few) are mostly just secondhand supposin' on the part of the old-timers.

A good example to start with is the naming of Billy the Kid. Much like Capitan residents insist Smokey the Bear is really just Smokey Bear, for a time Billy the Kid was simply either "Billy" or "Kid." It was in a fateful newspaper story in the *Las Vegas Gazette* on December 3, 1880, that he was for the first time referred to as Billy the Kid in print.

However, there is a more whimsical legend as to how the name was coined. It was said to have occurred around a campfire one night with Jesse Evans and his gang in the summer of 1877. Jim McDaniels made an allusion to Billy in conversation, and Evans asked, "Who?"

"Billy," McDaniels replied, "the Kid." The old article states, "It was an accident, the coining of the name, but it sounded strangely musical to McDaniels, and he said it over and over, 'Billy the Kid, Billy the Kid…'"[81]

DANDY DICK, FASTEST HORSE IN THE WEST

Just as the Lone Ranger had Trigger, Billy the Kid had Dandy Dick,[82] the name he gave his gray bay mare, taken from a character so named in a dime novel. In an FWP interview in 1938, Francisco Gomez of Lincoln recalled Billy's famous horse, which would come running whenever Billy whistled. "That horse would follow Billy and mind him like a dog. He was a very fast horse and could outrun most of the other horses around here."

Dandy Dick was largely romanticized by the *Las Vegas Gazette* in its serialized, mostly fictitious articles on the Kid and Lincoln called "The Forty Thieves." In it, Dandy Dick was called "the fastest horse in the West." The January 4, 1881 *Gazette* semi-factually reported on the horse's fate after Billy's capture at Stinking Springs, writing, "Everyone who has heard of Billy 'the Kid' has heard of his beautiful bay mare, about whose speed some remarkable stores have been told…When [Billy] was finally rounded up, he presented the mare to Frank Stewart, knowing that he would appreciate her as he certainly did, and he afterwards rode her in triumph to Vegas."

Sometime after that, a purported friend of the Kid's and owner of the Las Vegas Hot Springs, W. Scott Moore, gifted Stewart with a sixty-dollar revolver. Stewart, in turn, presented Billy's horse to Mrs. Moore. The couple at some point gave the horse to Minnie Scott, the hostess of the resort. In March 1881, the horse was taken by Edgar Caypless, who filed a suit of replevin against Moore for the recovery of the mare. At the time, Caypless was representing Billy at Santa Fe for his trial in regard to cattle and horse rustling; taking the horse by way of legal action was Billy's way of paying Caypless.

In opposition to this story is another told by Dr. Henry Hoyt, who claims he was given Dandy Dick long before the Kid's capture at Stinking Springs. In *A Frontier Doctor*, he writes:

> *The day of our departure Billy the Kid rode into Tascosa leading "Dandy Dick," a beautiful race horse, by far the choicest in his entire remuda de caballo, and to my great surprise made me a present of him. I had ridden*

him several times and admired him, but as he was Billy's favorite I never dreamed he would part with him…The origin of "Dandy Dick," however, remained a mystery. Billy never said where he got the horse.

Years later, the mystery of Dandy Dick was solved with the help of the "Cowboy Detective" himself, Charles Siringo. When Siringo showed James Brady, a descendant of Sheriff Brady living in Carrizozo, a bill of sale the Kid wrote out for Hoyt, Brady claimed it was his father's horse. Hoyt states, "The horse was of Arabian stock, well known locally as a racer, and had been owned formerly by Major Murphy." When elected sheriff, Lawrence G. Murphy gifted Dandy Dick to Brady.

It's possible that prominent rancher J. Phelps White relates a tale of Dandy Dick in Tascosa in some of his recollections, in which he wrote, "He [Billy] had what he called a race-horse with him. He hadn't been there an hour when he matched a race with old man Rhinehart's horse, 'Spider.' He was

THE RACE TO SAN ELIZARIO: FACT OR FICTION?

Though it's unknown if Billy would have been in possession of Dandy Dick at this time, the horse is commonly attributed to the Kid riding swiftly to San Elizario, Texas, to rescue his pal Melquiades Segura when he was seventeen. Supposedly, Billy rode eighty miles in only three hours to rescue his friend immediately upon receiving word that Segura was jailed there. Billy arrived in Sal Elizario around midnight and pounded on the jail door, insisting that he had American prisoners with him. When the guards opened the door, they were faced with Billy and his pistol and soon found themselves bound, gagged and tied to a post. Billy freed Segura and then threw the keys to the jail and the guards' guns on the roof. The duo of desperados then rode off for Mexico. Though this story appears in one of Upson's fictional chapters of *Authentic Life*, the real-life residents of San Elizario seem to believe this actually happened. The town constable of "the past thirty nine years," Antonio Trujillo, is quoted in a 1964 *Frontier Times* article by Jess Cox in which he points out the jail in which the incident happened to the author. Today, San Elizario even celebrates reenactments of the breakout for a Billy the Kid Festival held in the town, which also houses a bronze Billy the Kid statue on its grounds.

a race horse and we knew it. We didn't mean to beat him so badly but when we found out it was Billy the Kid we thought we'd better beat him good so there would be no squabble." And beat Billy's horse Spider did by a good fifty feet. Billy was a good sport about it and raised no objections.

Whatever happened to the legendary horse is unknown for sure, but an article from *Frontier Times* states, "Old-timers of Las Vegas reminisce nostalgically that Billy's mare never left the Vegas Grandes but remained to enliven the horse racing circles in the community until after her death."[83] Many years later, Dandy Dick's ghost would be seen alongside a spectral Billy at the Old Military Cemetery in Fort Sumner.

SAINT BILLY

One of the greatest folk tales of the Kid comes from Frank Applegate's book *Native Tales of New Mexico*. The story takes place on May 13, 1881, not un-coincidentally the day on which the Kid was to be hanged if not for his courthouse escape several weeks prior. Poor ragged Billy came to the small Spanish village of Escondida, where he sought refuge in the house of a Spanish man and his wife and daughter, Rosa. As Billy ate dinner with the family, Rosa whispered to her mother, "Perhaps he is a saint in disguise. He looks like the picture of the young archangel San Miguel,[84] in the church."

Billy noticed that the family was dressed nicely, as though they had planned to go out for the evening. Reluctantly, the father told Billy that they must all go to a *baile* being held by an evil thief and killer named Ruiz. When Billy said that he would tag along, the father begged him not to, for Ruiz had his sights set on his beautiful Rosa, and if Billy were to show up with them he feared Ruiz would kill Billy in jealousy. The family all expressed their disgust for Ruiz, the father lamenting that he should like to kill him. Billy urged the family to go on to the *baile* so as not to upset the dangerous man, while he would stay behind. "The three had no more than left the house before the young man drew the two six-shooters from their holsters and examined them," Applegate relates. Billy then creeped stealthily to the *baile*. As he entered the dance, he could see Ruiz making advances on Rosa. As Ruiz bowed to make his introduction to her, Billy stepped in her place. When Ruiz saw the Kid, he muttered in fear, "*El Chivato!*" The dance went silent as the others also whispered the name of El Chivato, Billy's nickname by the Spanish, in awe and surprise. "Yes, it is the Kid," Billy said of himself and

asked Ruiz why he didn't shoot him. Ruiz stammered in surprise about how the Kid was supposed to be hanged this very day. Billy told Ruiz he wouldn't shoot him so as not to mess up the floor with his "innards."

"You have three minutes in which to leave Escondida. I will know if you ever come back. Get," the Kid commanded, and off Ruiz went running, never to return. As the Kid left Escondida the next morning, the entire population bid him a cheerful farewell. Thanks to this folk tale, there was even talk of Escondida wanting to make Billy a saint. There is a settlement near Lincoln called Escondido and two places called Escondida nearer Socorro; it is not known for sure which of these three places the tale is set in.

SONS OF BILLY THE KID

Only one authenticated photograph exists of Billy the Kid, and nearly all who knew him concurred that it wasn't a good one. "I never liked the picture. I don't think it does Billy justice," Paulita Maxwell is quoted as saying in *Saga*. Despite his one bad picture, Billy had the reputation of a ladies' man. As such, he no doubt fathered at least one child, if not several. Not surprisingly, over the course of his interviews in New Mexico, Walter Noble Burns was rumored to have uncovered the identities of several of the Kid's progeny and their mothers, but his publisher discouraged him from publishing these scandalous revelations. Likewise, in her article "Romancing the Kid," Lynda Sanchez makes mention of secret conversations that stated, *"Los hijos de Billy todavia viven en San Patricio,"* or, "The sons of Billy still live in San Patricio."

One man who claims family heritage with the Kid is Elbert Garcia, author of *Billy the Kid's Kid: The Hispanic Connection.* Garcia outlines the Kid's heirs, starting with an Indian girl, Abrana Garcia, who had a son with the Kid in 1875, meaning Billy may have been only fifteen[85] when he fathered the child. Abrana was a sort of adopted sister to the Kid's pal Yginio Salazar, whose father, Petronillo Salazar, took her in. The child of this union with the Kid was said to be named Jose Patrocinio Garcia.[86] Next Billy allegedly knocked up Celsa Gutierrez, who gave birth to another son of the Kid in 1879.

Much like trying to pass off Brushy Bill as Billy the Kid, a lot of explaining has to be done to explain Billy's two offspring. The story goes that Billy went to Arizona after the conception of Jose Patrocinio Garcia. When Billy returned in 1877, the Lincoln County War broke out, so Abrana hid her son's true identity from the Kid and everyone else. In later

years, she concocted a fake birth certificate for Patrocinio, saying he was born in 1886, also the year listed on his grave marker. Eve Ball was said to have information on a son of Billy's who died sometime in 1968, but she withheld the family name out of respect. It is unknown, of course, if this is the family she was referring to, but in any case, to help keep the story of Billy's sons under the radar, the Garcia family concocted a story about Billy fathering twin girls to draw attention away from the boys.

Indeed, the myth that Billy sired two daughters was fairly popular in Fort Sumner. An old newspaper stated, "A tradition exists here of two golden-haired children whom their mothers proudly proclaimed to be Billy's. Both are said to have died in childhood from diphtheria. There is some doubt whether the children really existed, or if so, whether their father was Billy the Kid. He was not the only blond Anglo who came to Fort Sumner."[87]

Then there is the tale that Billy fathered a child with Juana Montoya, known as "La Tulida" due to her crippled arm. Research by author Don Cline turned up a June 3, 1880 census record in Lincoln County of a twenty-three-year-old Juana Montoya.[88] The woman is listed as having an illegitimate one-year-old son named Alexander Montoya (who some speculated was named after Alexander McSween). Supposedly this same son, who also went by Ramon, eventually murdered a man with an axe and was sent to a Santa Fe prison.

Billy's other illegitimate child dug up by Cline was daughter Florentina Yerby, not to be confused with one of the twin girls who died at an early age from diphtheria. Florentina often claimed to be Billy the Kid's daughter and was said to subsist on welfare rolls. Her mother was Nasaria Yerby, who worked as a maid at the Yerby Ranch, a confirmed hideout of the Kid and his gang. Nasaria was listed as being sixteen in 1880.

Finally, a curious obituary appeared in the April 7, 1987 edition of the *Albuquerque Journal* reporting the death of 102-year-old Vicenta Bonney. The obituary lists her as being "one of the last surviving relatives of Billy the Kid." If Billy was supposed to have been her father, then he would have had to have sired her in 1885, 4 years after he was dead.

BILLY'S LOST LOOT

Like all great outlaws, Billy left behind a small fortune that was never claimed after his death—or at least he did according to Deluvina Maxwell. "If I had the money that was buried with Billy I would want for nothing," Deluvina

said one day to some friends in her elder years.[89] Deluvina related a story that Billy had just won a "heap of money" in a poker game in a saloon across the street from Pete Maxwell's house. He stuffed the money in the waistband of his worn-out trousers and then the next day bought a new pair of pants. He took the new trousers to Deluvina, who always gladly did the Kid's sewing and laundry, and asked that she sew the money into their belt. According to Deluvina, Billy wore these trousers, money and all, the night he was killed. "When he was killed the money was buried with him," she said. While Billy was for a fact buried in his own trousers, many locals doubt this story to be true. Most detractors say Billy wouldn't be engaging in poker games while he was hiding out, nor did he have much, if any, money on him when he escaped from Lincoln. But if anyone would know, it would be Deluvina. John Meadows also claims that after his escape the Kid told him he needed to go up to Fort Sumner to win some money in poker games before retreating to Mexico.

There is also a tale of Billy returning from the dead to look for a lost cache he buried long ago. A man named Perry Lawson, who claimed to have ridden with the Kid in Lincoln County, said he had a surprise reunion with Billy in 1923 on the Montosa Ranch south of Magdalena. One evening, a man arrived at the ranch by automobile and asked to spend the night, and lonely Lawson was more than happy to oblige. As the two got to swapping old range tales, one was identical to an adventure Lawson had shared with—and only with—the Kid. As Lawson questioned his guest, he became more and more convinced that he was Billy. The sixty-something-year-old Kid claimed that after escaping Fort Sumner in 1881, he rode down to Mexico and stayed there a full fifteen years before returning stateside to the Tonto Basin in Arizona. The old *Frontier Times* article by Ben W. Kemp then goes on to state, "The Kid was headed for Lincoln County, New Mexico when he visited Lawson. He didn't say why, but Lawson suspected it was to dig up a stash that he had made in the 1870s or '80s. He might have dug up one two miles southeast of the old Morley White House, northwest of Datil."

Who knows, maybe after digging up his cache in Lincoln the Kid went up to Fort Sumner to dig up the poker cache buried with him hidden in his special *pantalones* sewn for him by Deluvina.

Billy Goes Bar-Hopping with Elfego Baca and Shooting with Temple Houston

Another gunslinger who may or may not have known Billy the Kid was Elfego Baca, the famed peace officer, lawyer and politician. Baca became a legend during the Frisco Shootout of October 1884. A deputy sheriff at the time, he arrested a drunken Anglo cowboy. In retaliation, friends of the man chased Baca down to an old adobe jackal, where he defended himself from, and miraculously survived, the onslaught of forty men until his surrender.[90] The house was riddled with four thousand bullets, and a door with four hundred bullet holes in it was used as evidence during a trial in which Baca was acquitted. The event is so well known that Walt Disney produced the TV miniseries *The Nine Lives of Elfego Baca* in 1958. Like the Kid, Baca was rumored to have known many legendary figures, and a story exists that he once stole a gun from Pancho Villa and Villa retaliated by placing a $30,000 bounty on his head.

Baca claimed that none other than Billy the Kid taught him to shoot and that the two shared an Albuquerque adventure together once. When the Kid was seventeen and Baca was sixteen (in fact, Baca was a good five years younger than the Kid), the duo walked from Isleta to Albuquerque, where they eventually wandered into the Martinez Bar in Old Town. In the middle of the noisy crowd, Billy would sporadically fire gunshots into the rafters to cause mischief. The bouncer suspected it was Billy, but when he searched him, he could find no gun. Later, Billy repeated the trick again, firing shots into the rafters, and again the bouncer searched him and found nothing. Once Billy and Elfego left, Billy revealed that he had hidden his stubby revolver underneath his large cowboy hat, the last place anyone would look.

Also rumored to be in the bar that day was a famed lawman of the area, Sheriff Perfecto Armijo, described by the *Optic* as a man who cast a chill "in the heart of every outlaw in New Mexico." Newspaper articles exist in May 1880 detailing Armijo's encounters with an outlaw called Kid, the first of which cryptically states, "Kid who was reported captured and killed at Santa Fe is alive and well and enjoying the hospitality of Sheriff Armijo."[91] The next article, published in the *Advance* on May 22, related how "Kid grew weary of the monotony of the county boarding house and Sunday started out for a trip in new regions. He did not leave a card, but a big hole in the wall served just as well to let the officials know they had looked their last on him." It should be noted that "Kid" was a common moniker in those days, and the outlaw from the *Advance*'s articles likely was someone else entirely rather than *the* Kid.

It would be remiss not to relate one other legendary character the Kid was said to know. A tall tale from Tascosa, Texas, has Billy in a shooting contest with Bat Masterson and Temple Houston. Masterson was a lawman famous for his time spent in Dodge City, Kansas, among other things, while Houston was the son of the legendary Sam Houston. Houston won the shooting contest between the three, with the Kid proving to be a gracious loser. Frederick Nolan points out in his *Tascosa: Its Life and Gaudy Times*, however, that the Kid was dead long before Houston came to Tascosa.

BILLY THE KID: CROSS-DRESSER AND DISGUISE EXTRAORDINAIRE!

When news on the Kid becomes sparse and there is nothing new to discuss, some parties turn to wild speculation to fill the void. For instance, there is the story that because of Billy's small hands and wide hips he was really a woman in disguise. Also pertinent are allegations that he often "washed up" on his own apart from the other men. As for where this rumor could have come from, there do exist stories about Billy dressing up as a woman to fool the law. During an interview with Brushy Bill researcher William Morrison, Severo Gallegos claimed that Billy once disguised himself as a woman to get inside a jail where his friend Lucas Gallegos was being held to bust him out, and according to Severo, it worked.[92] Jesus Silva, one of Billy's pallbearers, also claims that the Kid used his blue eyes, blond hair and small hands to fool the occasional lawman into thinking he was a girl.[93] Then there is the story that Billy used to dress himself up in the bonnet of Maximiana "Panita" Anaya Salazar—Yginio's wife. In *Billy the Kid's Kid: The Hispanic Connection*, author Elbert A. Garcia writes that "Billy would disguise himself in Panita's bonnet and long dress and walk out of their house to overlook the terrain watching for the posse." Though he never claimed Billy to be a woman, Yginio Salazar said he "had the face of an angel" and "the soft voice of a woman."[94]

As for other interesting disguises and hiding places the Kid was prone to, Paco Anaya says he once buried Billy in a hole with a bush over his face as a posse came by looking for him. Yet another unique hiding place he found once was under a girl's big hoop skirt. Billy was also a master of disguise in other ways that did not involve cross-dressing. Once he supposedly pretended to be a cripple hobbling around on a cane, and yet another tale says he grew a beard to look like an old man.[95] The Kid's

obituary published in the July 28, 1881 *Grant County Herald* reported that "since his escape from the Lincoln jail he had allowed his beard to grow, and had stained his skin to look like a Mexican."[96]

Variations on the Killing of Joe Grant

One of the Kid's most famed killings was that of Joe Grant. Grant was a rough-and-tumble cowboy who once said to the Kid, "I'll bet twenty-five dollars that I kill a man today before you do." It was a threat, not a bet. Later, when Grant grew heavily inebriated in a saloon, the Kid sidled up next to him and lifted his revolver. "That's a mighty nice six-shooter you got there," he said as he conveniently spun the revolver to an empty chamber. He gave the gun back to the drunken Grant, and the inevitable pissing contest between the two began. Finally, when Grant had had enough, he pointed his gun at the Kid and fired. Only nothing happened on the empty chamber. The Kid then quickly shot him three times in the face. "Good joke on him," the Kid was said to say, and later when someone would ask him to explain the incident, "His gun wouldn't fire, and mine did." Supposedly his aim was so perfect that there was only one hole in Grant's head. The story makes up one of the more famous scenes in *Young Guns II* and is more or less accurately portrayed. Like his courthouse escape, alternate stories also exist for this deed.

Yginio Salazar possibly relates a non-fatal version of the Joe Grant story. In his tale, an unnamed hombre in an unnamed saloon came in looking to assassinate the Kid. The man, pretending to be drunk, insisted that Billy have a drink with him. His plan was to shoot Billy once he took his drink, only Billy threw his whiskey in the man's face and told him, "Let's play the trick over. You drink this time. Let's see whether I can get you!" The man mentioned having to go see someone about a horse and ran out of the saloon with Billy yelling to him, "Better luck next time, fellow! You are not the only one who has failed to get me. Even old Pat Garrett hasn't got me yet." Meanwhile, Yginio and his friends laughed with delight.[97]

Then there is Frank Lloyd's tale of "Texas Red" out to get Billy outside a Fort Sumner saloon during a shooting contest when "all of us were as drunk as four hundred dollars," according to Lloyd. Approaching the Kid, Red said, "Billy, I'll draw first blood for the drinks." "I'll go you," Billy said and then immediately "broke his neck."

Zeke Castro's *An Outlaw Called Kidd* tells an interesting variation of the Grant incident, only in this story, the man is named Charlie Wilson. In this version, Billy doesn't pull the revolver trick and instead just beats him to the draw. As Wilson falls over, Billy quips, "Don't fall. Pay me the drinks you owe me. Some die just so they don't have to pay." Again, his cohorts erupted into boisterous laughter.

Yet another variation on the Joe Grant killing claims that Grant was a bounty hunter for John Chisum after the Kid, only he didn't know what he looked like. While bragging in a bar that he would eventually kill the Kid, unbeknownst to him the Kid was there and heard him. The Kid went up to Grant to admire his pistol, famously fixing it as in the other stories before giving it back to him and then calmly telling him who he was. Deluvina Maxwell says Grant told Billy that Chisum had paid him to kill him, and Billy replied, "I'll pay you." Billy then pulled out his pistol and shot him. The *Las Vegas Optic* gave the best account of the story's aftermath: "Rudolph asked Billy what occasioned the trouble and he remarked: 'Oh, nothing; it was a game of two and I got there first.' The daring young rascal seemed to enjoy the telling as well as the killing. But he will not run at large on the plains seeking victims any longer. His career will probably be checked by a halter."

And so it eventually was.

THE GHOST OF BILLY THE KID STALKS FORT SUMNER

Shortly before Billy's death, according to Deluvina Maxwell, Pete Maxwell and the Kid played a trick on Maxwell's servant Antonio Malino, who falsely believed Billy to have been killed after his escape from Lincoln. To play the trick, Billy hid behind a door in a lonely room of the Maxwell house and began calling to her. Malino began to scream as she heard the Kid's voice, and when Billy appeared before her, Malino said, "I thought you were dead." A short time after that, the Kid was shot dead by Garrett in the same house. Eerily, it is claimed by Jesus Silva that Billy's dead body did not begin to bleed until a full two hours after the shooting.

As famous as the Kid is, tales of his ghost are somewhat sparse, though ghostly happenings have been attributed to the Old Military Cemetery thanks to native superstition. "They say it's haunted. Some folks'll drive a mile out of their way at night to keep from passin' it," said Charlie Foor of

Artist Jared Olive's rendition of the Ghost of Billy the Kid. *Jared Olive, Delta FX.*

the cemetery, called Hell's Half Acre by some, in Burns's lavishly embellished *Saga*. Deluvina Maxwell, for one, was wildly superstitious and would not pass the cemetery herself after dark, claiming to have seen the ghost of a buffalo soldier there once but never Billy.

Burns gives a characteristic vivid description of the Kid's grave, then a barren patch of land devoid of a proper marker:

The bare space is perhaps the length of a man's body. Salt grass grows in a mat all around it, but queerly enough stops short at the edges and not a blade sprouts upon it. A Spanish gourd vine with ghostly gray pointed leaves stretches its trailing length toward the blighted spot but, within a few inches of its margin, veers sharply off to one side as if with conscious purpose to avoid contagion. Perfectly bare the space is except for a shoot of prickly pear that crawls across it like a green snake; a gnarled bristly, heat cursed desert cactus crawling like a snake across the heart of Billy the Kid. "It's always bare like this," says Old Man Foor, standing back from this spot as if half-afraid of some inexplicable contamination. "I don't know why. Grass or nothin' else will grow on it—that's all. You might almost think there's poison in the ground."

Foor even suggests that cracks in the hard dry earth make out the picture of a skeletal hand reaching out from certain angles. Burns goes on to concur, perhaps merely for the delight of his readers, that he, too, sees "the sun-drawn skiagraph" that is somehow stretching from the alleged grave. However, in a later interview with the *Southwestern Dispatch* in July 1928, Foor admitted that he and Burns were "just talking," implying they had embellished the ghostly grave's descriptions. Ironically, after his death in 1940, Foor was himself buried in the same cemetery.

Saga also includes a brief comical episode on the Maxwell family involving the Kid's ghost shortly after his death in the chapter "The Belle of Old Fort Sumner." One night, Paulita and Pete Maxwell with a neighbor, Manuel Abreu, were sitting inside when they heard the sound of soft footsteps walking across the front porch, as if someone were creeping along in their stocking feet. "Can it be that the Kid has come back from the dead?" an excited Abreu asked. Pete Maxwell chimed in and remarked, "Every night since his death I've heard queer noises about the old house." Paulita was the voice of reason among the men, who were perhaps just trying to scare her, and chided them for their foolishness. "But Paulita, they say the spirits of murdered men return to haunt the place where they were killed," Abreu continued. The footsteps began again, and Maxwell crossed himself: "Billy the Kid's ghost!" Finally having enough, Paulita went outside to investigate only to find it was a jackrabbit. It is reported in other stories that Pete really did fear the ghost of Billy, for when it came time to sell his ranch a short time later to the New England Cattle Company, Maxwell insisted he could not sell Billy's favorite horse, Old Don, or "Billy, dead these three years, would rise up in his grave and curse me."[98]

An old *True West* article by artist Lea F. McCarty relating his trek to Fort Sumner to find a picture of the Kid's funeral mentions tales of Billy's

Many of the tall tales in this book were created and recounted in cattle camps such as this one. Pat Garrett is the man labeled as "1". *HSSNM, #566.*

ghost several times but fails to go into detail on them. The closest the article gets to a bona fide Billy ghost sighting comes from a conversation between McCarty and Tom Sullivan,[99] a clerk at the Billy the Kid Curio Shop near the grave. McCarty asked why the property owner never sold the cemetery to the state, to which Sullivan replied, "They don't want it." He then leaned in close to elaborate: "He bent over to whisper with the wind howling outside…'Some say [the owner] is afeard of Billy's ghost. It's been seen, you know, by some of the folks around here. Mr. Austin saw it, so he says, riding one night across the old fort ruins and carrying the wooden cross. He rode the beautiful grey he was so proud of. *Duerme bien querido.*'"

The Spanish phrase whispered by Sullivan at the end is the inscription "Rest in peace, beloved," said to be on the original cross marking the Kid's grave. When Sullivan went on to recount the poor long-gone cross's elaborate history, he mentioned how Paulita Maxwell once stole it to win a bet. "That wouldn't have been me sir! I've seen Billy's ghost myself, but I don't expect you to believe it!"

NOTES

Chapter 1

1. Colonel Jack Potter, "Death and Burial of Billy the Kid," in Nolan, *Billy the Kid Reader*, 341.
2. *Billy the Kid: Las Vegas Newspaper Accounts*.
3. Stahl, "Lower William Hale and Joshua Fred Hale."
4. The myth that Garrett exhumed the Kid's body to ascertain this was spread by Charles Siringo in his *History of Billy the Kid*.
5. Stahl, "The Mysterious Journey of Billy the Kid's Trigger Finger."
6. The story is related in Burns, *Saga of Billy the Kid*. For those who think Burns exaggerated Paulita's interview, she gives the same exact story to Otero in *Real Billy the Kid*.
7. Deluvina Maxwell is also credited with stealing the Kid's cross rather than Paulita. However, this is most likely false, as Paulita says in Otero, *Real Billy the Kid* that Deluvina considered the theft of the cross "sacrilege."
8. Another article also written by Potter says the inscription was "Billy the Kid (Bonney) July 14, 1881."
9. Tom Sullivan, who worked at the Billy the Kid Curio Shop in the 1950s, claims some of these bodies also went to Roswell, which is unlikely.
10. Nolan, "Here He Lies," 23.
11. It's likely this Hale was related to L.W. Hale, who supposedly sold Billy the Kid's trigger finger to the *Las Vegas Optic*, as the Hales were a prominent family in Ruidoso and good friends with the Coes.
12. It's the author Zeke Castro's opinion that this occurred in 1883 rather than 1905–6.
13. Jameson, *Billy the Kid: Beyond the Grave*, 81.

14. A statue was eventually erected in Billy the Kid's likeness in San Elizario, Texas, near El Paso.
15. "How Billy the Kid Taught Ranchman Just 'A Lesson' With a Six Shooter." HSSNM newspaper clipping dated December 15, 1926.
16. Hendron, *Story of Billy the Kid*, 3.
17. Melzer, *Buried Treasures*, 184.
18. The June 20, 1976 article "Bandit's Tombstone Returned" by Frank Stanley says the footstone was donated by Twentieth Century Fox in 1940.
19. Associated Press, "The Kid's Stone Brought Home," June 3, 1976.
20. Carson, "Billy the Kid's Restless Bones."
21. Sharpe, "Officials Struggle."

CHAPTER 2

22. No one ever claimed to be Fountain; rather, newspapers published reports of sightings of Fountain after his disappearance from White Sands in 1896. The most colorful story alleged he was in Cuba aiding in the revolution of the time.
23. Airy, *Whatever Happened to Billy the Kid?*, 140.

CHAPTER 3

24. Evans would be hired by the Santa Fe Ring faction to oppose Billy and his Regulators during the war.
25. Walker points out the similarity between the name Billy Barlow and Charlie Bigelow, J. Frank Dalton's "patsy," in his book *Legends and Lies*.
26. Frank Lobato was a man at whose sheep camp Billy stayed shortly before his death. Lobato was interviewed in Otero, *Real Billy the Kid* but certainly doesn't mention Roberts's story.
27. Payne, "When Did the Lincoln County War Actually End?"
28. Sonnichsen and Morrison, *Alias Billy the Kid*, 57.
29. This photograph is published in Dixon, "Source Surfaces to Connect Billy-Jesse."

CHAPTER 4

30. It is implied in this story, taken from Kemp, "Ride for Mexico, Billy!" that Garrett also thinks he has shot the Kid and is only an unknowing participant in the conspiracy.
31. Among those given lessons were *True West* editor Bob Boze Bell's aunt in the Deming area.
32. Dobie says he expired while crawling toward a mountain, presumably to find a cave to die in.

CHAPTER 5

33. Metz, *Pat Garrett*, 122.

34. George Coe certainly didn't voice this opinion in his autobiography *Frontier Fighter*, in which the Kid stays dead.

35. Kadlec, *They "Knew" Billy the Kid*, 88.

36. Sonnichsen and Carter, "Neighborhood Talk About Pat Garrett."

37. FWP interview by Frances E. Totty, February 14, 1938, with Charles Roark.

38. In a further elaboration of this story, the spy was said to be looking for Billy the Kid in order to collect the $30,000 reward on his head.

39. Castro, *An Outlaw Called Kidd*. In another section of *Outlaw Called Kidd*, Castro implies Richards thought this man was specifically John Miller.

40. *Albuquerque Journal*, "Old Timers Who Saw Coffin and Knew Pall Bearers Say Billy the Kid Is Dead," June 23, 1933.

41. Potter, "Reminiscences of the Socorro Vigilantes."

42. Telephone interview with Cox, February 08, 2015.

CHAPTER 6

43. Chappell, "Ruidoso's Old Mill."

44. Sonnichsen and Morrison, *Alias Billy the Kid*, 41.

CHAPTER 7

45. Electromagnetic Frontier, "Jesse James III," electromagneticfrontier.blogspot.com/2009/05/jesse-james-iii.html.

46. Brushy Bill always spoke of a sidekick named Indian Jim who at one point in 1890 sent Roberts to a boxing school in Cincinnati, Ohio. Could this have been Jim Thorpe?

47. Walker, *Legends and Lies*, 104.

48. Dalton has alternately been stated to have died in Granbury or an Austin, Texas nursing home.

49. Also called the Adobe House.

50. The good doctor gave Billy a gold watch strung on a long chain of braided hair that he claims can be glimpsed in Billy's famous tintype.

51. Despite being the Kid's "friend," Mr. Moore donated $100 to a collection for Garrett when the state failed to pay him the $500 reward owed to him for the killing.

CHAPTER 8

52. O'Connor, *Pat Garrett*, 48.

53. George Coe spins a tale that Billy refused the offer for a pardon and that when Wallace asked him to lay down his guns, Billy spun his revolver and quipped, "Governor, this is the only protection I have—A pardon would not do me any good."

54. Osthimer, "Stealing a Territory—The Hidden Rape of the West," vol. 2, "The Cover-Up Behind the Legend of Billy the Kid," 33.
55. It should be noted that these two sons were born after Garrett's killing of the Kid. Also, Garrett himself was killed when the boys were still very young.
56. E-mail to the author, November 12, 2014.

CHAPTER 9

57. The *Democrat* lists him as killing eighteen men and twenty-one men by his own account.
58. P. Donan, "Billy the Kid," *Grant County Herald*, July 29, 1881.
59. H.H. Whitehill, the Silver City sheriff who first arrested Billy the Kid in Silver City as a boy, stated in a 1905 interview that he heard that in addition to killing Windy Cahill, the Kid also shot down two soldiers who were herding the post's horses in cold blood and then took the horse he liked best to escape.
60. Otero, *Real Billy the Kid*, 104.
61. He is also identified as George Griggs, owner of the Billy the Kid Museum in Mesilla.
62. Tales of Billy having a sister originated in the *Las Vegas Optic*.
63. Hendron, *Story of Billy the Kid*, 3.
64. J. Frank Dobie, excerpt from "A Vaquero of the Brush Country," in Dellinger, *Billy the Kid*, 38.
65. Morgan Nelson says he recalls hearing that it was John Jones who was hired to do away with the squatters.
66. Cronyn, "Who Really Shot Billy the Kid?"

CHAPTER 10

67. These contradictions were somewhat heatedly debated by Walter Noble Burns and Maurice G. Fulton in a series of letters.
68. Upon hearing of the Kid's escape, Garrett was said to have remarked, "Now I've got to do it all over again."
69. A letter from Roswell in the May 2 *Optic* says it occurred on Thursday evening.
70. Bell Hudson, a prisoner of Garrett's at the same time, claimed card playing with Billy the Kid was positively forbidden by Garrett.
71. John Tuska postulates that Coe used *Saga of Billy the Kid* to fill in the blanks of his memory.
72. Some insist that George Coe, in his *Frontier Fighter*, left out the details of the hidden gun in the privy specifically to protect whomever left it there because Coe knew them.
73. This originates in the May 3, 1881 *Las Vegas Optic*, "The Double Tragedy."
74. In one rendition, long before the shooting takes place, Olinger quips to Garrett not to worry while he's away and that he'd fill Billy full of buckshot if he tried anything. Billy was said to respond, "Maybe you'll be the one to get that buckshot instead of me."

75. Allegedly even Olinger's own mother said, "Bob was a murderer from his cradle, and if there is a hell I know that he is there."

76. The Kid was purported to have said, "The sonsofbitches might shoot me, but they will never hang me" after being sentenced.

77. Hendron, *Story of Billy the Kid* mentions the Kid having the same type of poison on him in the Santa Fe jail several months earlier. It was said to have been delivered to the Kid on April 16.

78. Castro, *An Outlaw Called Kidd.*

79. Burroughs, *On the Trail*, 28.

80. Burroughs, "Billy the Kid's Stolen Horse."

CHAPTER 11

81. Vance Johnson, "Famous Outlaw's Name Was Coined by Accident," undated newspaper clipping from HSSNM.

82. It should be noted that Billy's horse, more often than not unnamed, is oftentimes described as female and was likely a separate horse from Dandy Dick.

83. Callon, "Billy the Kid's Last Christmas."

84. Fort Sumner, where Billy was eventually killed, was coincidentally located in San Miguel County.

85. It should be stated it's not 100 percent certain that Billy was in fact twenty-one years old when he died. He himself claimed to be twenty-five in a census prior to that.

86. Abrana later had a son with Pablo Antonio Anaya in 1879; they named him Pedro Antonio Garcia.

87. Hunter, "Collect Funds for Monument."

88. This woman is also rumored to be the daughter of Juan Patron, who threw her out of the house for her amorous ways.

89. Hunter, "Collect Funds for Monument."

90. Later in life, Baca claimed it was eighty men.

91. The May 9, 1881 *Las Vegas Optic* also once jumped the gun, claiming the Kid was killed in El Paso by a Marshall Studemier.

92. Sonnichsen and Morrison, *Alias Billy the Kid*, 23.

93. Another New Mexico outlaw named Abram Baca also once escaped from the law by dressing up as a woman in Socorro in the same era that Billy made headlines. Often in Baca's company was an outlaw also known as "Kid," who was eventually lynched by a Socorro vigilante mob.

94. Smith, "Amigo of Billy the Kid."

95. Garcia, *Billy the Kid's Kid*, 39.

96. Hertzog, *Little Known Facts About Billy, the Kid*, 25.

97. Smith, "Amigo of Billy the Kid."

98. Kadlec, *They "Knew" Billy the Kid*, 122.

99. Frederick Nolan believes he may have actually been Ed Sweet in his article "Here He Lies."

BIBLIOGRAPHY

BOOKS

Airy, Helen. *Whatever Happened to Billy the Kid?* Santa Fe, NM: Sunstone Press, 1993.

Anaya, Paco. *I Buried Billy.* College Station, TX: The Early West, 1991.

Bell, Bob Boze. *The Illustrated Life and Times of Billy the Kid.* Phoenix, AZ: Tri-Star Boze, 1992, 2004.

Billy the Kid: Las Vegas Newspaper Accounts of His Career, 1880–1881. Waco, TX: W.M. Morrison Books, 1958.

Branch, Luis Leon. *Billy the Kid y los Billitos.* N.p.: self-published, 1976.

Brent, William. *The Complete and Factual Life of Billy the Kid.* New York: Frederick Fell, Inc., 1964.

Bryan, Howard. *Wildest of the Wild West: True Tales of a Frontier Town on the Santa Fe Trail.* Santa Fe, NM: Clear Light Publishers, 1991.

Burns, Walter Noble. *The Saga of Billy the Kid.* New York: Doubleday, Doran and Company, 1929.

Burroughs, Jean. *On the Trail: The Life and Tales of "Lead Steer" Potter.* Santa Fe: Museum of New Mexico Press, 1980.

Castro, Zeke. *An Outlaw Called Kidd: The Reality of Billy the Kid.* Montgomery, AL: E-Book Time, LLC, 2012.

Cooper, Gale. *Billy the Kid's Pretenders: "Brushy Bill" & John Miller.* Albuquerque, NM: Gelcour Books, 2010.

————. *Mega Hoax: The Strange Plot to Exhume Billy the Kid and Become President.* Albuquerque, NM: Gelcour Books, 2010.

Cox, William H., II. *The Adventures and Times of William H. Cox II "Billy the Kid."* New York: iUniverse, Inc., 2010.

Dellinger, Harold, ed. *Billy the Kid: The Best Writings on the Infamous Outlaw.* Helena, MT: TWODOT, 2009.

BIBLIOGRAPHY

Dobie, Frank J. *Apache Gold and Yaqui Silver*. Boston: Little, Brown and Company, 1939.

Fleming, Elvis E. *Treasures of History IV: Historical Events of Chaves County, New Mexico*. New York: iUniverse, Inc., 2003.

Fleming, Elvis E., and Ernestine Chesser Williams. *Treasures of History II: Chaves County Vignettes*. Roswell: Historical Society for Southeast New Mexico, 1991.

Garcia, Elbert A. *Billy the Kid's Kid: The Hispanic Connection*. Santa Rosa, NM: Los Products Press, 1999.

Hendron, J.W. *The Story of Billy the Kid*. Santa Fe, NM: Rydal Press, 1948.

Hertzog, Peter. *Little Known Facts About Billy, the Kid*. Santa Fe, NM: Press of the Territorian, 1964.

Hoyt, Henry F. *A Frontier Doctor*. New York: Houghton Mifflin Company, 1929.

Jameson, W.C. *Billy the Kid: Beyond the Grave*. Dallas, TX: Taylor Trade Publishing, 2005.

Kadlec, Robert F., ed. *They "Knew" Billy the Kid*. Santa Fe, NM: Ancient City Press, 1987.

Keleher, William. *The Fabulous Frontier*. Santa Fe, NM: Sunstone Press, 2008.

MacDonald, A.B., and Fred E. Sutton. *Hands Up! Trues Stories of the Six-Gun Fighters of the Old Wild West*. New York: A.L. Burt Company, 1926.

Meadows, John P., and John P. Wilson, ed. *Pat Garrett and Billy the Kid as I Knew Them*. Albuquerque: University of New Mexico Press, 2004.

Melzer, Richard. *Buried Treasures: Famous and Unusual Gravesites in New Mexico History*. Santa Fe, NM: Sunstone Press, 2007.

Metz, Leon. *Pat Garrett: The Story of a Western Lawman*. Norman: University of Oklahoma Press, 1974.

Miller, Jay. *Billy the Kid Rides Again: Digging for the Truth*. Santa Fe, NM: Sunstone Press, 2005.

Nolan, Frederick. *Tascosa: Its Life and Gaudy Times*. Lubbock: Texas Tech University Press, 2007.

————. *The West of Billy the Kid*. Norman: University of Oklahoma Press, 1998.

Nolan, Frederick, ed. *The Billy the Kid Reader*. Norman: University of Oklahoma Press, 2007.

O'Connor, Richard. *Pat Garrett: A Biography of the Famous Marshal and Killer of Billy the Kid*. New York: Curtis Books, 1960.

Otero, Miguel Antonio, Jr. *The Real Billy the Kid*. Houston, TX: Arte Publico Press, 1998.

Shinkle, James D. *Reminiscences of Roswell Pioneers*. Roswell, NM: Hall-Poorbaugh Press, 1966.

Sonnichsen, C.L., and William V. Morrison. *Alias Billy the Kid*. Albuquerque: University of New Mexico Press, 1955.

Tuska, John. *Billy the Kid: His Life and Legend*. Albuquerque: University of New Mexico Press, 1997.

Walker, Dale. *Legends and Lies: Great American Mysteries of the American West*. New York: Tom Doherty Associates, Inc., 1997.

MAGAZINES AND NEWSPAPERS

Bowley, Dana. "Fort Sumner Goes on Offensive in Battle Over the Kid's Grave." *Roswell Daily Record*, July 10, 1988.

BIBLIOGRAPHY

Breihan, Carl W. "The Day Billy the Kid Was Killed." *Real West*, December 1974.

Burroughs, Jean. "Billy the Kid's Stolen Horse." *New Mexico Magazine*, May 1981.

Callon, Milton W. "Billy the Kid's Last Christmas." *Frontier Times*, December–January 1968.

Carson, Kit. "Billy the Kid's Restless Bones." *Real West*, March 1962.

Chappell, Virginia. "Ruidoso's Old Mill." *New Mexico Magazine*, February 1956.

Cline, Don. "The Secret Life of Billy the Kid." *True West*, April 1984.

Cox, Jess. "Valley of the Conquerors." *Frontier Times*, March–April 1964.

Cronyn, George. "Who Really Shot Billy the Kid?" *Real West*, September 1966.

Dixon, Lee. "Source Surfaces to Connect Billy-Jesse." *Roswell Daily Record*, September 6, 1981.

Dobie, J. Frank. "My Two Favorite Stories about Billy the Kid." *Rocky Mountain Empire Magazine*, February 5, 1950.

Hunter, H.S. "Collect Funds for Monument at Grave of 'Billy the Kid.'" Undated newspaper clipping, HSSNM Archives.

Kemp, Ben W. "Ride for Mexico, Billy!" *Frontier Times*, February–March 1980.

Lyon, Fern. "The Lost Padre Treasure of Victorio Peak." *New Mexico Magazine*, May 1976.

McCarty, Lea F. "Why Is It So Important That There Is a Photograph of Billy the Kid's Funeral?" *True West*, November–December 1960.

Nolan, Frederick. "Here He Lies." *Western Outlaw Lawman Association* (WOLA) *Journal* (Spring 2003).

Osthimer, K.F. "Billy's Tombstone Has Weird History." *Roswell Daily Record*, February 15, 1981.

Payne, Vernon. "When Did the Lincoln County War Actually End?" *Tinnie's Historical Roundup* (April 1982).

Potter, Chester D. "Reminiscences of the Socorro Vigilantes." *New Mexico Historical Review* 40, no. 1 (January 1965).

Rasch, Phillip J. "The Bonney Brothers." *Frontier Times*, December–January 1965.

Rosson, Mary'n. "The Gun That Killed Billy the Kid." *Old West*, Winter 1970.

Sanchez, Lynda. "Romancing the Kid." *New Mexico Magazine*, January 2002.

Sharpe, Tom. "Officials Struggle with Replacing Signs, Placards and Even Tombstones." *New Mexican*, February 11, 2009.

Sinclair, John L. "The Hasty Career of the Copycat Kid." *New Mexico Magazine*, February 1993.

Smith, Wilbur. "The Amigo of Billy the Kid." *New Mexico Magazine*, April 1936.

Sonnichsen, C.L. "Pat Garrett's Last Ride." *True West*, November–December 1958.

Sonnichsen, C.L., and A.G. Carter. "Neighborhood Talk About Pat Garrett." *Old West*, Fall 1970.

Sproull, Robert. "Various Authors of Billy the Kid's Escape." *Past Perfect: Access Yesterday, the Era of Billy the Kid* (January 2012).

Stahl, Robert J. "Lower William Hale and Joshua Fred Hale." *Lincoln County, New Mexico Tells Its Stories*. Lincoln, NM: LCHS, 2012.

———. "The Mysterious Journey of Billy the Kid's Trigger Finger." *True West*, June 2013.

St. George, Phil. "Was the Kid a Cold Blooded Killer?" *New Mexico Magazine*, August 1960.

BIBLIOGRAPHY

LETTERS, INTERVIEW TRANSCRIPTS AND MANUSCRIPTS

Fulton, Maurice G. "The Grave of the Kid and Its Marker." October 7, 1937. Historical Society of Southeast New Mexico.

Haley, J. Evetts. Interview with Deluvina Maxwell. June 24, 1927.

———. Interview with Frank Lloyd. August 18, 1927.

Maurice G. Fulton Papers, correspondence between Fulton and Walter Noble Burns, Special Collections, University of Arizona Library.

Osthimer, Kenneth F. "Stealing a Territory—The Hidden Rape of the West Volume II: The Cover-Up Behind the Legend of Billy the Kid." 1981.

White, J. Phelps. "Recollections of Ranching Operations in New Mexico with George W. Littlefield." March 1933.

WEBSITES

American Life Histories: Manuscripts from the Federal Writers' Project, 1936–1940. www.loc.gov/collection/federal-writers-project/about-this-collection.

INDEX

INDEX

INDEX

INDEX

ABOUT THE AUTHOR

John LeMay is the author of six books on the history of Roswell, southeastern New Mexico and the Southwest, including *The Real Cowboys and Aliens: UFO Encounters of the Old West* (co-authored with Noe Torres); *Legendary Locals of Roswell* (co-authored with Roger Burnett); *Roswell, USA: Towns That Celebrate UFOs, Lake Monsters, Bigfoot and Other Weirdness*; and three titles in Arcadia's Images of America series, including *Roswell, Chaves County* and *Towns of Lincoln County*. Though born in Roswell, LeMay is a direct descendant of both James W. Patterson, postmaster of Fort Sumner, and John Edwin Lobley, a Fort Sumner farmer. LeMay is a past president of the Historical Society for Southeast New Mexico in Roswell, and he has already started work on a companion volume to this book: *Tall Tales and Half Truths of Pat Garrett*.